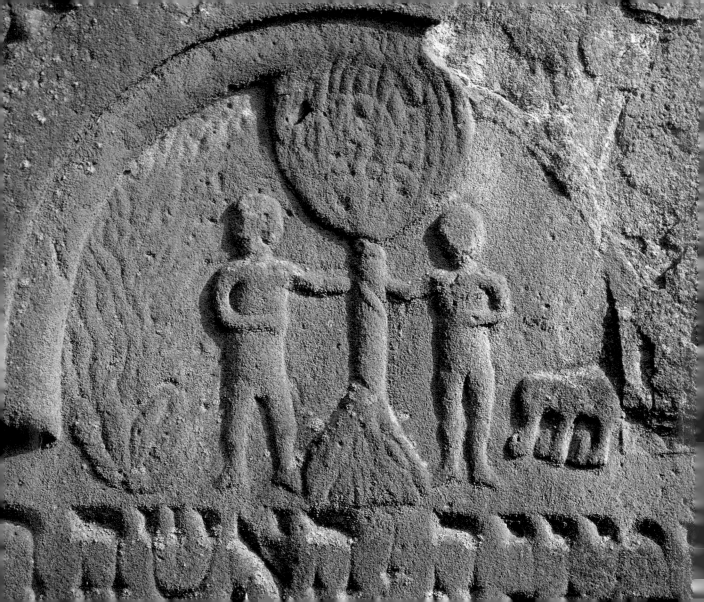

GRAVEN

ARNOLD SCHWARTZMAN

GRAPHIC
MOTIFS
OF THE
JEWISH
GRAVE
STONE

FOREWORD BY CHAIM POTOK

IMAGES

HARRY N. ABRAMS, INC., PUBLISHERS

Endpapers:
An engraving from
a drawing by Jacob
van Ruisdael of
the Portuguese
cemetery.
Ouderkerk,
Netherlands
COURTESY THE ISRAEL
MUSEUM. JERUSALEM

Page 2:
Adam and Eve
in the Garden of
Eden. This scene
is frequently used
to represent the
name Chavvah
(Eve). The elephant
is a Jewish symbol
of creation.
14th century,
Frankfurt am Main,
Germany

Opposite:
Engraving
showing motifs
found in the 17th-
century Velho
Cemetery. London,
England
COURTESY THE MANSELL
COLLECTION, LONDON

Page 6:
The golem—in
Jewish folklore,
a human being
made of clay.
Frankfurt am Main

Editor: Sharon AvRutick
Assistant Editor: Jennifer Stockman
Design and Photography: Arnold Schwartzman

Library of Congress Cataloging-in-Publication Data

Schwartzman, Arnold.
 Graven Images: graphic motifs of the Jewish gravestone /
Arnold Schwartzman; foreword by Chaim Potok.
 p. cm.
 ISBN 0–8109–3377–2
 1. Jewish art and symbolism. 2. Sepulchral monuments—
Themes, motives. 3. Stone carving—Themes, motives. I. Title.
N7415.S27 1993
736'.5'089924—dc20 92–23883
 CIP

Published in 1993 by Harry N. Abrams, Incorporated, New York
A Times Mirror Company

Printed and bound in Hong Kong

TO THE MEMORY OF
MY PARENTS,
DAVID AND ROSE
SCHWARTZMAN

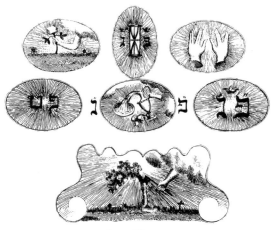

Jew Tombs
Whitechapel.

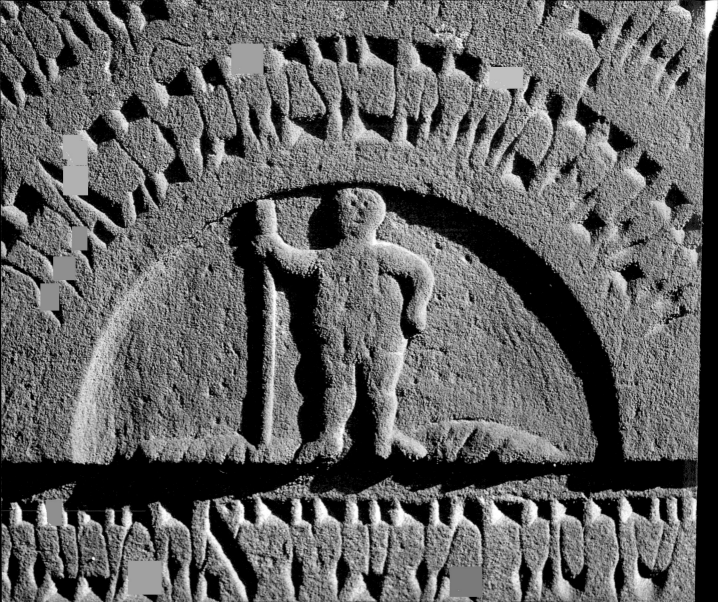

CONTENTS

FOREWORD

We have all seen gravestones—small and large, modest and lavish, plain and adorned. Directly behind my brother's home in New York State is a graveyard dating to the Revolutionary War: low narrow whitish headstones leaning toward the grassy earth; barely discernible names and dates. The Catholic cemetery in the hill village of Saint-Paul-de-Vence, in southern France: richly flowered; treed with tall cypresses; dense with close-set ornamented tombs. The Jewish cemetery in Nice: stone and marble hot and shimmering beneath the Provence sun. The cemetery near Kowloon: headstones of children who perished in a plague; and their parents; entire families side by side; names, dates.

We remember our dead.

Normally, we enter a cemetery not to stay and ponder but to inter and depart. On those occasions when we linger with our buried dead we commune with souls, not stones. And so—a book about images on tombstones? Questions surely arise. Turn these pages. Image after image ascend to our eyes. One must therefore ask the obvious: How in the light of all this are we to understand the second commandment?

That commandment (Exodus 20:4–5) tells us: "You shall not make for yourself a sculpted image, or any likeness of what is in the heavens above, or on the earth below, or in the waters under the earth. You shall not bow down to them or serve them."

Is the image forbidden in homes, schools, and synagogues but permitted in cemeteries? Did our forefathers avoid images in life only to accept them in death?

This statue of Moses pointing to the second commandment was erected in 1790 to replace the one built in 1544 as a caution against idolatry. Bern, Switzerland

8

Another question: Gaze closely at the pictures in these pages. Sheep, lions, eagles, dragons, griffins, scorpions, cats, wolves, snakes, deer, storks, a lobster, a half lion and half fish, birds of prey, skeletons, grapes, citrons. Whence this rich array of images? Are they persistent echoes of mythological bestiaries? Or pagan and Christian fantasy and fable? In *Jewish* cemeteries?

Yet another question: Virtually none of the cemeteries in these pages exists in a viable contemporary Jewish community. The sun-splashed Mediterranean world of Sephardi Jewry—gone. The austere and learned Northern realm of Ashkenazi Jewry—gone. Of what value to us are graven images in sites from which the quotidian rhythms and vitality of Jewish life have been erased?

Indeed, bluntly, why *any* sort of book on graven images? Surely there are less doleful subjects that might lay claim to our time and attention.

What, precisely, is that forbidden object, the "sculpted image"?

A careful look at the writings of Jewish authorities on this most significant of subjects leads one to the conclusion that tradition is not of one mind regarding what constitutes an image.

Some authorities interpret the second commandment as forbidding only those images made by a Jew for worship by a Jew, while at least one commentator asserts that the verse applies even to images a Jew might create for non-Jews to worship.

Some take "sculpted" to mean incised as well as built up; others seem to regard it only as three-dimensional. Some speak of "image" as referring to the human form; others see it as intending any form.

Is a painting an image? Only if it is full face, not a profile, according to some. Others regard any depiction of the human face as an image.

On a passage in the Talmud (Rosh Hashanah 24a) in which there is an account of pictures of the phases of the moon used for the purpose of establishing the precise time of the new moon, a sage asks: "Is that permitted? Isn't it written [in Exodus 20:20], 'With Me, therefore, you shall not make any gods of silver, nor shall you make for yourselves any gods of gold'—meaning, you shall

not make a form of any of my servants [like the moon]?" Another sage responds: "The Torah forbade only those servants of which a likeness can be made [and no one can make a precise likeness of the light of the moon; hence, an image of the moon is not forbidden]."

Clearly there seems to be no unanimity in the Jewish tradition on the matter of images.

Witness the images in the Temple of Solomon, in the Bet Alfa, Israel, and Dura-Europos, Syria, synagogues, in medieval manuscripts and Passover Haggadahs, and on the walls of the great synagogues of Poland.

As art became progressively associated with the Christian world, as it entered into the core of Christendom and became an instrument in the spread of Christian teaching, Jewish authorities grew increasingly hostile to it. Yet there seems never to have been any universal prohibition against involvement with art. True, the depiction of the human figure met with strong disapproval—yet it is found in Haggadahs, and even on tombs. Indeed, one of the most astonishing ironies in this connection is the image on the Spanish and Portuguese tomb of Moses de Mordechai, 5490 (1730), in Ouderkerk, Netherlands. (A detail of that gravestone is reproduced in this volume on page 20.) It depicts, in baroque style, Moses bringing down the Ten Commandments, flanked by Abraham and King David. Ponder this: a sculpted image of Moses carrying the commandments in which the sculpted image is forbidden!

All the legal authorities appear to agree on this point: Art made for the purpose of idolatrous worship is forbidden. Beyond that we are in the compass of legitimate disagreement and tenuous interpretation. And in that world labored the sculptors who created the extraordinary art found in Jewish cemeteries and in the masterful pictures in this volume.

Why tombstones, and whence the images?

Our species marks its gravesites. Prehistoric nomads, tillers of land, dwellers in cities buried their dead. The oldest of cities, Jericho, dating to the end of the last Ice Age about ten thousand years ago, yielded to archeologists clay skulls with human faces. On the coast of ancient Canaan

(now Israel) have been found ossuaries with engravings of human features.

Few in the ancient world really grasped the essential nature of death, its utter finality. It was generally thought to be a gateway to another realm where some new and perhaps variant form of life awaited us. After all, the dead were seen in dreams and appeared in memory. Certainly they lived on, probably as invincible, inscrutable, aggressive spirits possessed of limitless and frightening power for healing or havoc. Ought one not therefore appease them with gifts of food and drink?

One buried with the dead whatever it was felt they would require in their new life. In ancient Egypt, one spent one's life building a proper tomb and ensuring its perpetual care after one's death. In ancient Canaan, a nobleman's sword and steed accompanied him into the grave. During the time of the Patriarchs—about the second millennium B.C.E.—wandering tribes placed offerings in the graves of their dead.

Abraham purchased a permanent gravesite, an indication that his wanderings were at an end. Jacob placed a monument at the grave of Rachel, the first tombstone mentioned in the Bible. During the period of the Israelite and Judean kingdoms, royalty, nobility, and prophets were buried in sepulchers and marked graves.

After the return from Babylonian exile, and especially during the Hasmonean period (in the second and first centuries B.C.E.), tombstones became increasingly flamboyant, probably under Greek and Roman influence. That prompted a Talmudic sage to order that "one ought not erect monuments (*nefashot*) to the righteous, for their words are their memorial," a view concurred in by Maimonides and disputed by a leading medieval legal authority, Solomon ben Abraham Adret, who regarded the tombstone as a mark of honor for the dead. Isaac Luria, the greatest of Jewish mystics, esteemed the tombstone as an aid in the "perfection of the soul."

Beginning with the second century B.C.E., inscriptions and ornamentation were commonplace on tombstones both inside and outside the land of Israel. Exquisite ornamentation adorns the Tombs of the Sanhedrin (members of the ancient Jewish high court).

After the fall of Rome and the end of the classical period, Jewish tombstones throughout much

of the Western world became stark, unadorned, and often contained at most a crude depiction of a menorah or an eternal light. During the Middle Ages even this meager embellishment vanished, giving way to the sole presence of Hebrew letters.

In Germany, France, Poland, Russia, and England, the lands of Ashkenazi Jewry, tombstones were as a rule vertical; in the Sephardi Jewish regions of Spain, Portugal, and North Africa, they tended to be horizontal.

The high period of tombstone art commenced with the Renaissance. Ashkenazi tombstones almost never showed the human figure. But Sephardi Jews in Amsterdam and the West Indies would be buried in graves under stones often densely decorated with bas-relief depictions of biblical scenes echoing the life of the deceased: A man named Isaac, as an example, has on his tombstone a sculpture of the binding of Isaac. In Curaçao, in the Netherlands Antilles, a deathbed scene found its way onto a tombstone. And another Sephardi gravestone contains a sculpture that purports to be the likeness of a deceased husband and wife.

Symbols populated Ashkenazi tombstones.

Jews of Poland and Bohemia often buried their leaders in sarcophagi. The grave of a Hasidic master would be protected by a hutlike edifice of wood or stone. One sees on the tombstones of Polish Jews, in the wake of the terrible massacres of the mid-17th century, a rush toward the baroque. The ornate became the order of the day; tombstones began to resemble the decorated walls of great wooden synagogues. And by the early 18th century, most Jewish tombstones in Ashkenazi lands contained a commonality of ornamentation: lavish fruit baskets, elaborate floral adornments, as well as a range of familiar and widely understood symbols.

The grave of a *kohen* (a member of the priestly class) would bear the carving of a pair of hands raised in the act of delivering the priestly benediction. The grave of a Levite would be marked by the depiction of a basin or a vase-shaped jug (Levites washed the hands of priests before the public delivery of the benediction), or by a musical instrument (during the time of the

First and Second Temples, Levites accompanied the sacrificial rites with songs).

A man of learning would have an open book on his stone. A scribe would lie beneath a stone on which a parchment and a goosefeather would be depicted. Chains and a crown marked the grave of a goldsmith. Shears for a tailor; a violin or harp for a musician; a mortar and pestle for an apothecary; a lion and a sword for a physician; a candelabrum for a pious woman; a charity box for a philanthropist or collector of charities; a sun and moon for a Kabbalist; an eagle with a circumcision knife for a *mohel* (circumciser).

The lobster (page 126) on the tombstone in Vienna—what did that represent? Someone under the aegis of Cancer?

Often the name of the deceased would be translated into its equivalent symbol for a bird, fish, or animal: a deer for Hirsh; a lion for Leib; a bird for Jonah; a fish for Fischel.

Dragons, monkeys, and griffins seemed to emanate from some primal apocalyptic bestiary. Skulls and skeletons were symbols of mortality. Sometimes an adornment was identical to the emblem of the house where the deceased had lived. (There were no street numbers; people identified one's house by the emblem over one's door.)

The tombstone was usually set up no earlier than a year after the date of death: the length of time thought to be necessary for the soul to be cleansed of sin. The Jewish dates carved into the stone counted from the time of Creation. In some instances Christian years were placed alongside the Jewish ones.

Today, that vast array of symbols is gone, and in most of the Western world there are virtually no discernible differences, other than the use of Hebrew letters, between Jewish and non-Jewish tombstones.

The artists who carved and created those tombstones were an anonymous breed of individuals who labored with chisel, mallet, and stone at the task of combating the terror and oblivion of the grave. They sought to give each deceased person his or her due; to mark in death the paths trodden in life.

Much of the sculptors' work is startling in its mastery; some of it goes beyond craft into the subtler realm of art. Variation and prodigality of symbolism and decoration abound, as if they were entirely without fear of condemnation for idolatry.

One wanders through these hallowed cemeteries with a reverberating sense of history and with feelings of awe for the sculptor's art. Here, in the very presence of death, gifted hands were at work, some giving expression to unique visions of the world.

Thus did those nameless sculptors try to blunt, soften, neutralize, assuage, delay, and redeem the cold and pitiless touch of death.

To the extent that we are able to witness their work in a book such as this, read the names on the tombs they created, and gaze at these graven images—to that extent it may be said that they succeeded. Through their art they join us to our echoing past and help us touch the most human aspects of our deepest selves.

Chaim Potok

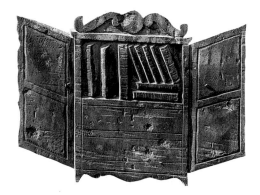

A bookcase is a motif used to represent a person of learning, such as a rabbi or a writer. 19th century, Warsaw, Poland

INTRODUCTION

There is an old Yiddish saying, "Az men kumt iber di plankn, krigt men andere gedanken." (When you've climbed the fence, other thoughts commence.)

Thus it was some twenty years ago, while making a documentary film in the village of Ouderkerk, Netherlands, I was about to shoot the hoisting of a Dutch tricolor atop a church steeple. Seeking a better vantage point for our cameras, I climbed over a fence. There I discovered a number of horizontal white marble gravestones buried in the tall grass. Bearing inscriptions in Hebrew and Portuguese, they were covered with incredibly detailed representations of scenes from the Bible.

I later learned that this was the 17th-century cemetery of the Sephardic (Spanish and Portuguese) community of Amsterdam. Some of the monuments of their cousins, the twenty-three "Jewish Pilgrim Fathers" of Nieuw Amsterdam, remain in New York's Lower East Side's Shearith Israel Cemetery, the first Jewish burial ground in America, founded in 1654.

In 1852, Henry Wadsworth Longfellow noted, after visiting the 200-year-old Touro Cemetery in Rhode Island: "Nearly all are low tomb-stones of marble; with Hebrew and a few words added in English or Portuguese." Two years later, in his poem "The Jewish Cemetery at Newport," he would write:

> And these sepulchral stones, so old and brown,
> That pave with level flags their burial place,
> Seem like the tablets of the Law, thrown down
> And broken by Moses at the mountain's base.

This, and my similar discovery at Ouderkerk, inspired the odyssey that would take me over 100,000 miles—from John o'Groat's to Jerusalem, from the Carpathians to the Catskills, over fences and walls, and under hedgerows—to seek and document further sepulchral images.

This book is the distillation of my wanderings. It contains a selection from over ten thousand photographs I have taken of Jewish memorials in nineteen countries. I have chosen to concentrate on the monuments of European Jewry—a two-thousand-year-old legacy—detailing in particular the motifs to be found in Austria, Czechoslovakia, Denmark, England, Germany, Netherlands, Hungary, Italy, Poland, and Romania. I have divided the photographs into three chapters relating to the areas proscribed by the second commandment: the heavens above, the earth below, and the waters under the earth. All reveal varying degrees of liberality in the interpretation of this prohibition.

I liken my findings to painter Eliezer Lissitzky's discovery on first entering the 16th-century Mogilev synagogue in Belorussia, which he describes in his diary of 1922: "The walls were painted [with] . . . fish hunted by birds; the fox carrying a bird in his mouth; birds carrying snakes in their beaks; a bear climbing a tree in search of honey; and all intertwined with acanthus plants that bloom and move on the walls of the wooden synagogue. Beyond the masks of four-legged animals and winged birds, there are the eyes of human beings. This is the most characteristic aspect of Jewish folk art."

As Lissitzky and his contemporaries Chaim Soutine, Jacques Lipchitz, Marc Chagall (whose ancestor, Isaac Segal, had painted the walls of the Mogilev synagogue), Camille Pissarro, and Amedeo Modigliani (both products of the Sephardic world) metaphorically straddled their ghetto and shtetl walls in order for their art to flourish in a secular society, so I climbed back over these walls to satisfy my curiosity about the work of the Jewish folk artists who had synthesized synagogue ornamentation with folk craft. I found graven images in profusion on the memorials— hallowed milestones that plot the course of the Jewish diaspora.

The Mogilev was only one of many European synagogues that were destroyed during the Nazi holocaust; the ancient synagogue of Worms, Germany, depicted on a mural in the Mogilev, was also destroyed. During the Middle Ages, Worms had been a major center of Jewish learning.

This city's Jewish cemetery, its earliest gravestone dating from 1076, miraculously survived the holocaust as a result of a visit in the 1930's from SS leader Heinrich Himmler. During his visit, Himmler was escorted around Worms by the town's archivist, Dr. F. M. Illert. The archivist must have caught Himmler's imagination, as he expressed great interest in the cemetery's historic significance. Later, when the Nazis decided to build on the site, Dr. Illert warned them that Himmler had a special interest in the cemetery's preservation and suggested that the builders contact Berlin for permission before proceeding. Not wishing to incur the SS leader's disfavor, the builders abandoned their plan.

Inset into the walls of this cemetery, alongside the gravestones of the twelve Jewish councillors murdered by Christian crusaders in 1096, are fragments of gravestones desecrated after the plague of 1349, when Jews were libeled with poisoning the city's wells.

Not least among the many restrictions placed upon the Jews during the Middle Ages were those related to burial. Frequently, Jewish communities had to run a gauntlet just to reach the few designated areas allowed them. In England, prior to 1177, the cemetery in Jewen Street, St. Giles Cripplegate, London, served the whole of the country. Inevitably violating the Jewish laws pertaining to expedient interment, the mourners had to endure physical attacks during their often long journeys as they passed through towns and villages.

The only burial ground for the whole region of Bavaria was in Regensburg. Not being permitted to pass through towns, burial processions from the outlying communities took their own special routes through fields and woods, which Jewish merchants also used as trade routes, causing the gentiles to create mystical legends about these paths.

In Holland, prior to 1614, the only burial ground for Jews was in Groet.

Tolls were often charged when Jewish funeral processions passed churches; such was the case in Venice, Italy. On the journey from the ghetto, via the Rio di Cannaregio, to the cemetery on the Lido, the processions had to avoid passing under the bridge of San Pietro di Castello, as hostile

citizens often threw refuse onto the flotilla of funeral gondolas.

Through the centuries, the vandalism, desecration, and obliteration of Jewish cemeteries—"eternal" resting places—has mirrored the persecution of the Jews themselves.

The old city walls of Fürth, Germany, were built out of Jewish gravestones following the banishment of this city's Jewish community. In England, the memorials of the exiled Norman Jewry were used to build cathedrals.

In the 16th century, Egyptian Mohammedans were known to steal Jewish tombstones and, after erasing the inscriptions, resell them to the Jews. To end this practice, the rabbis insisted that only newly quarried stone be used for monuments.

In the late 18th century, Napoleon Bonaparte commandeered sections of the Jewish cemetery of San Nicolo del Lido, in Venice, to construct coastal defenses. During World War II, Nazis paved roads with Jewish gravestones; likewise, prior to the Six-Day War, Jordanian soldiers desecrated memorials on Jerusalem's Mount of Olives, using them to build roads and latrines.

London's Nova, or "Cherry Tree," Cemetery (named after the orchard that originally occupied this site), founded in 1733, was partially demolished by enemy bombing in September 1940—the same time my family home was destroyed on neighboring Sidney Street.

In a Jewish cemetery in Los Angeles, a recent incident was found to be the work of a security company wishing to be awarded the contract to protect the cemetery. Nineteenth-century gravestones in this same cemetery, removed from the original site—where Dodger Stadium now stands—suffered severe damage during the 1987 Whittier Narrows earthquake. And, from The Hills of Eternity Jewish cemetery in northern California, Tombstone City's gunfighter Wyatt Earp's gravestone has been stolen on three occasions.

On the Caribbean island of Curaçao, two thousand gravestones in a 17th-century Sephardic cemetery have been eroded by the pollution caused by an adjacent oil refinery. One fears for the 3rd-century Hellenistic cemetery in war-torn Sarajevo.

In the face of all this destruction, it is nothing short of a miracle that any of these monuments

remains today. Still, some one thousand Jewish cemeteries remain in Germany alone, 350 in Poland, a similar number in Czechoslovakia, and hundreds more throughout Europe. Efforts are now being made to preserve what is left. In Poland, for example, donations from individuals and an apportionment of the state lottery go toward the repair and preservation of the country's remaining Jewish cemeteries.

What does the future hold? An accepted liberal interpretation of the second commandment prohibition is that the graven or sculpted image not be in the round. Will punctilious Jews eventually succumb to modern-day technology and circumvent the injunction by adopting the Japanese innovation of affixing holograms (three-dimensional images) to the memorials of their loved ones?

Recently, having returned to photograph the cemetery at Ouderkerk (which is now in possession of a fax machine—the ultimate transgression?), I noticed that the sunlight reaching through the leaves of the trees was producing a wonderful dappled effect on a tomb engraved with the image of Moses. As a shaft of light fell precisely upon the second commandment inscribed on the tablets held by the Patriarch, I thought how perfect a photograph of this scene would be for the cover of this book. As fate would have it, a few days later my camera and the roll of film containing this image were stolen at a train station in Germany. An act of divine intervention?

Turn-of-the-century enameled photograph on a memorial shattered by zealots. Cimitero Nuovo, Venice

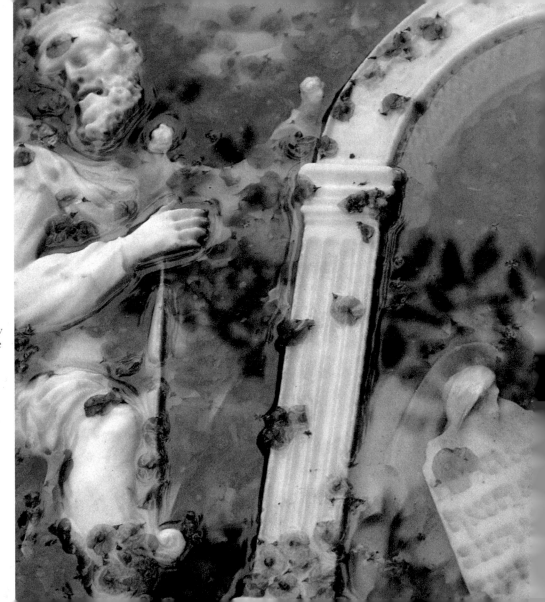

Revere God and observe His commandments! For this applies to all mankind...
ECCLESIASTES 12:13

The second commandment prohibits the making of graven images.

Right:
Detail of a magnificent baroque Sephardic (of Spanish or Portuguese origin) gravestone depicting Moses and the Ten Commandments. Moses is flanked by King David and the prophet Abraham. Tomb of Moses de Mordechai, dated 5490 in the Jewish calendrical system, which begins with the Creation. 1730, Ouderkerk, Netherlands

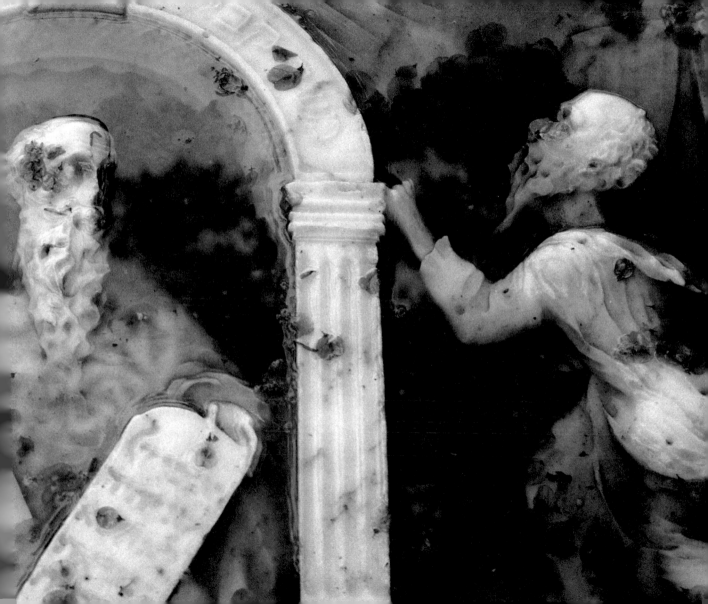

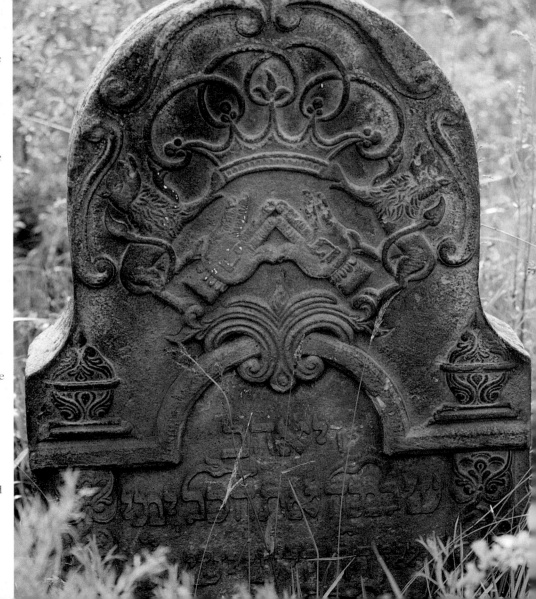

*Lift your hands
toward the
sanctuary and bless
the Lord.*
PSALMS 134:2

Kohanim, members
of the priestly tribe
of Aaron, have
always played an
important ritual role
in the temple.
Today, at particular
services, they bless
the congregants.
Neither the priests
nor the worshipers
are permitted to
look at the priestly
hands. The
kohanim raise their
hands over their
heads, fingers
separated to form
openings through
which the blessed
Shekhinah (radiance
of God) streams
down upon the
congregants.

Right:
Hebrew lettering
decorated with
birds' heads.
Mszczonów, Poland

Opposite:
1891, Michalovce,
Czechoslovakia

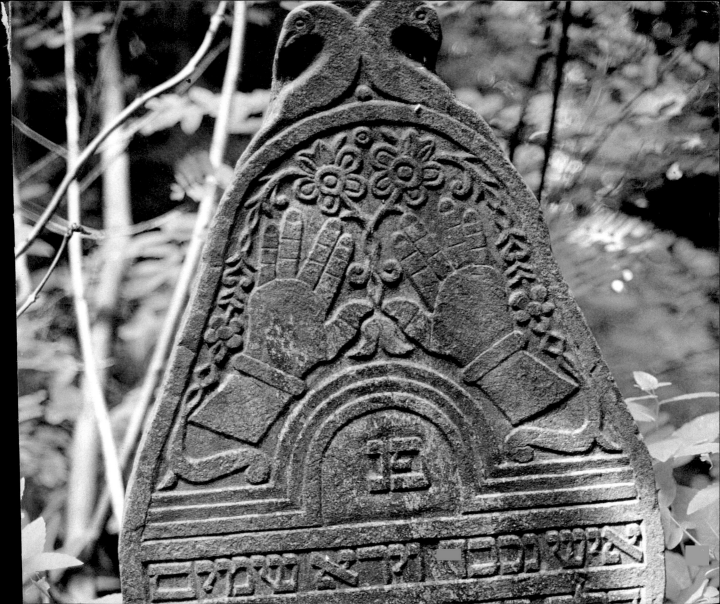

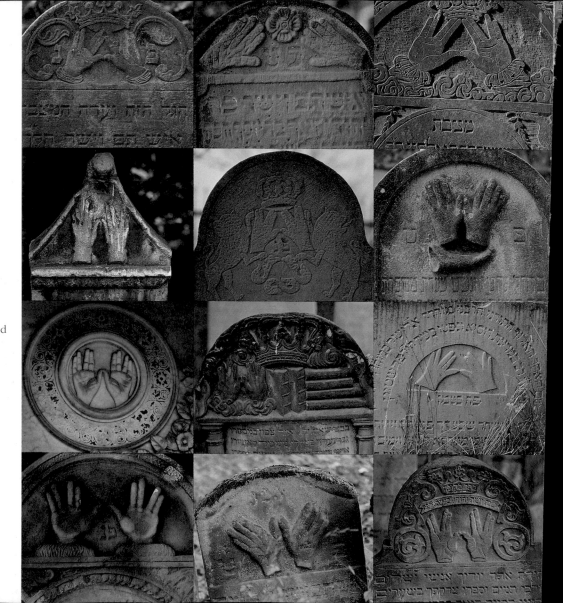

Left to right:
1. Tarnów
2. Weikersheim
3. Warsaw
4. Warsaw
5. Venice
6. Warsaw
7. Höchberg

1. Kraków
2. Bobowa
3. Weikersheim
4. Venice
5. Szydlowiec
6. Starachowice
7. Weikersheim

1. Venice
2. Warsaw
3. Georgensgmünd
4. Sulzbach-Rosenberg
5. Höchberg
6. Weikersheim
7. Kraków

1. Warsaw
2. Weikersheim
3. Tarnów
4. Weikersheim
5. Weikersheim
6. Höchberg
7. Prague

24

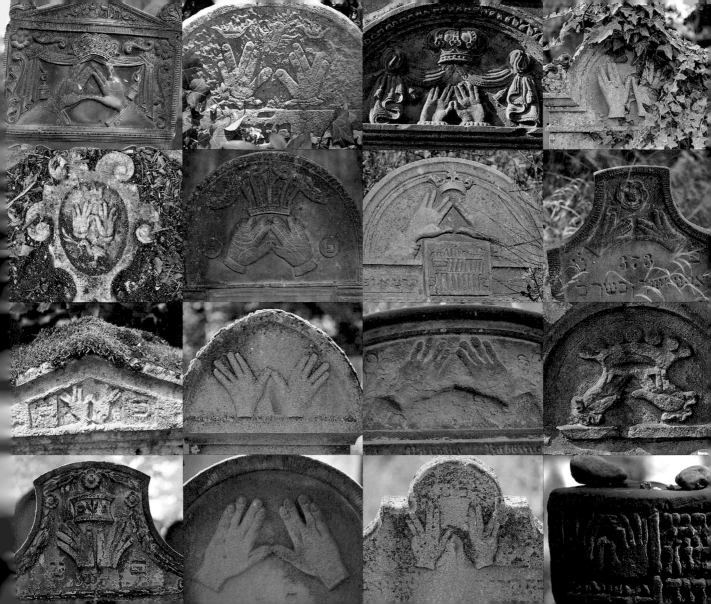

The priests and Levites purified themselves; then they purified the people....
NEHEMIAH 12:30

The Levites (descendants of Levi, one of Jacob's twelve sons) were required to assist in the religious duties in the Temple, such as pouring water from the ritual ewer onto the hands of the *kohanim.* They also were musicians, choristers, and gatekeepers. Today, the Levites are honored in the synagogue by being called second, after the *kohanim,* in the reading of the Torah (Scroll of the Law).

Right:
Gesia Cemetery, Warsaw

Opposite:
Guru Humorului, Romania

26

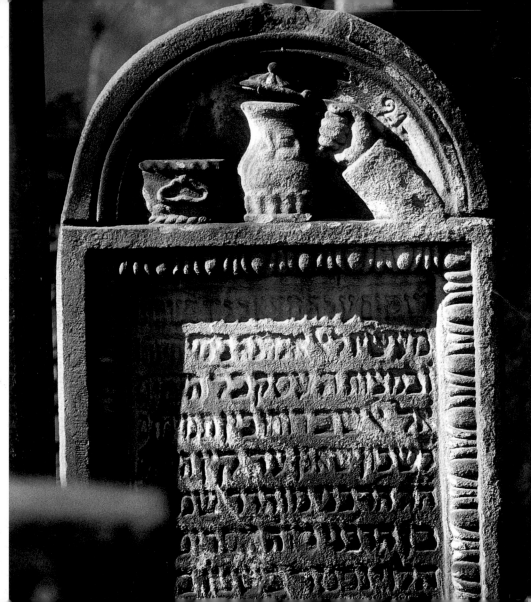

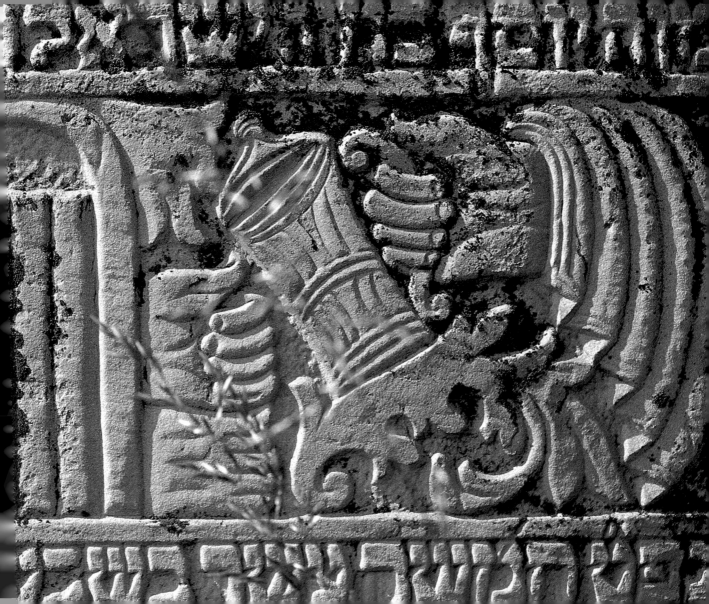

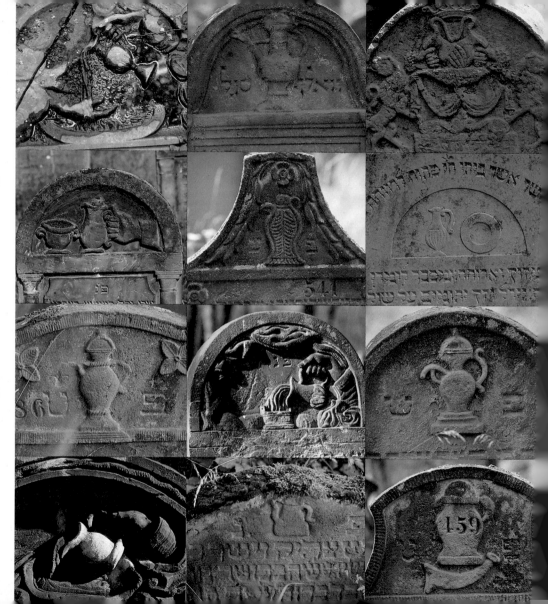

Left to right:
1. Ouderkerk
2. Weikersheim
3. Kraków
4. Unterbalbach
5. Kraków
6. Weikersheim
7. Warsaw

1. Wachock
2. Weikersheim
3. Georgensgmünd
4. Unterbalbach
5. Wachock
6. Rödelsee
7. Warsaw

1. Weikersheim
2. Warsaw
3. Weikersheim
4. Starachowice
5. Worms
6. Sulzbach-
 Rosenberg
7. Guru Humorului

1. Warsaw
2. Weikersheim
3. Weikersheim
4. Eisenstadt
5. Unterbalbach
6. Vienna
7. Fălticeni

28

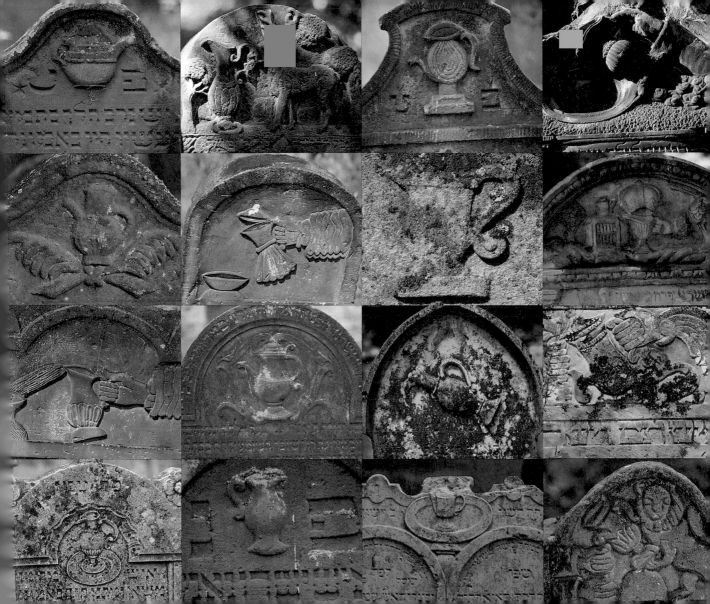

*Make a laver
of copper...*
EXODUS 30:18

Above:
The ewer and laver, symbols of the Levites, a household emblem over a doorway in the Jewish ghetto. Eisenstadt, Austria

Right:
1730, Weikersheim, Germany

Opposite:
Unterbalbach, Germany

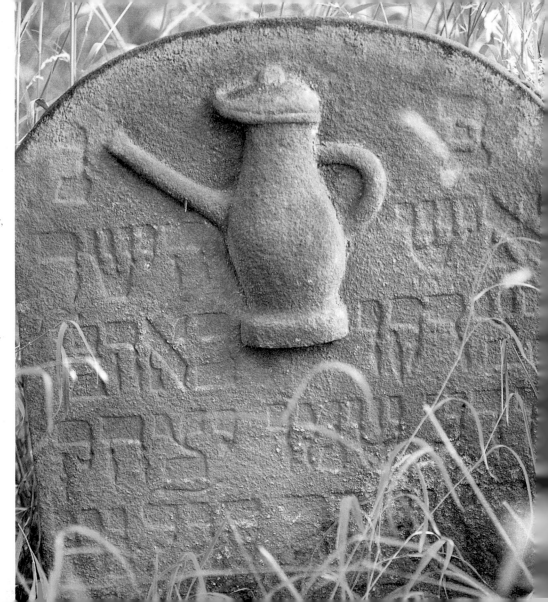

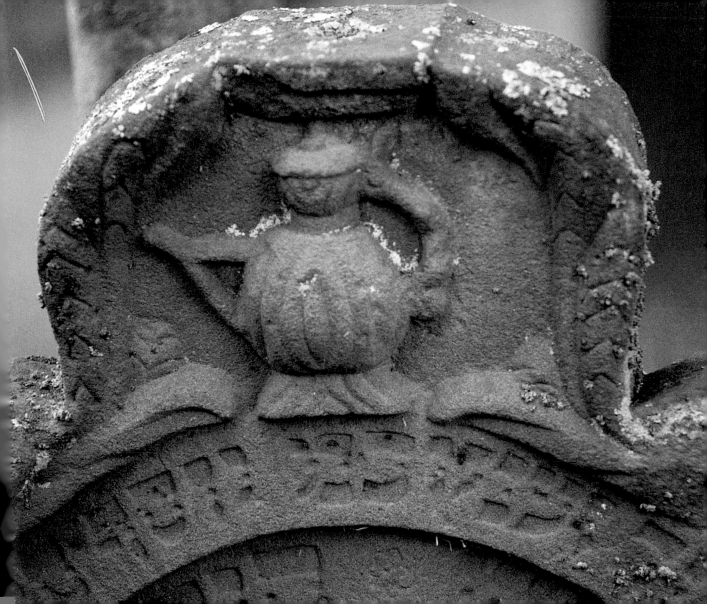

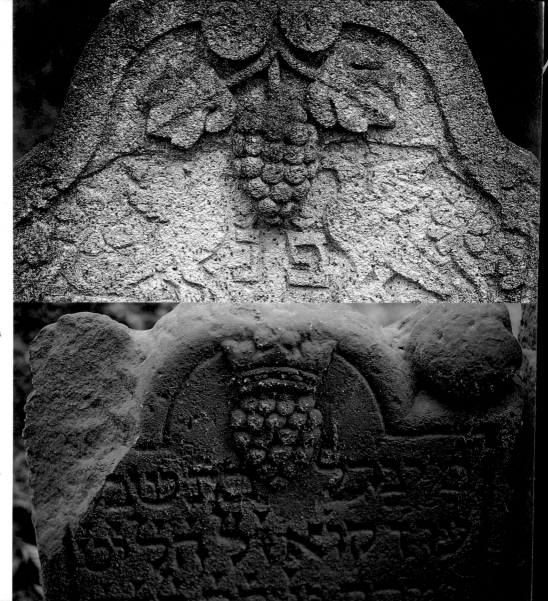

They reached the wadi Eshcol, and there they cut down a branch with a single cluster of grapes—it had to be borne on a carrying frame by two of them....
NUMBERS 13:23

Top:
Another symbol of the tribe of Levi is a cluster of grapes. Sighet, Romania

Bottom:
Old Jewish Cemetery, Prague, Czechoslovakia

Opposite:
Two naked "spies" wearing hats. Moses sent Joshua out as one of the "spies" to investigate the fertility of the Promised Land. Made from the indigenous *pietra d'Istria* (stone of Istria). San Nicolo del Lido, Venice, Italy

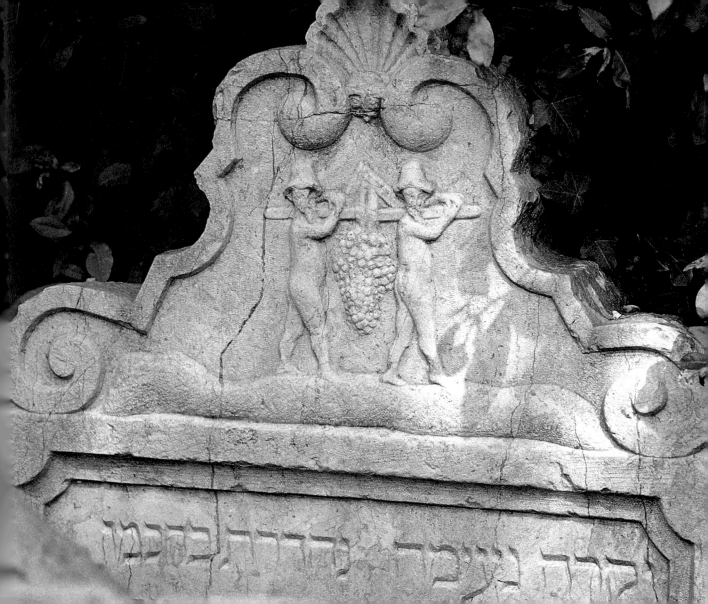

*And there in
[the dove's] bill
was a plucked-off
olive leaf!*
GENESIS 8:11

After their expulsion
from Spain in 1492,
the dispersed
Sephardic
communities
interpreted the
commandment
regarding graven
images more
liberally. Hence-
forth, biblical scenes
relating to the
namesakes
of the deceased
proliferated.

Top:
Noah sends a dove
to see if the flood
has receded.
San Nicolo del Lido,
Venice

Bottom:
Noah's ark.
Frankfurt am Main

Opposite:
Abraham prepares
to sacrifice Isaac.
Ouderkerk,
Netherlands

34

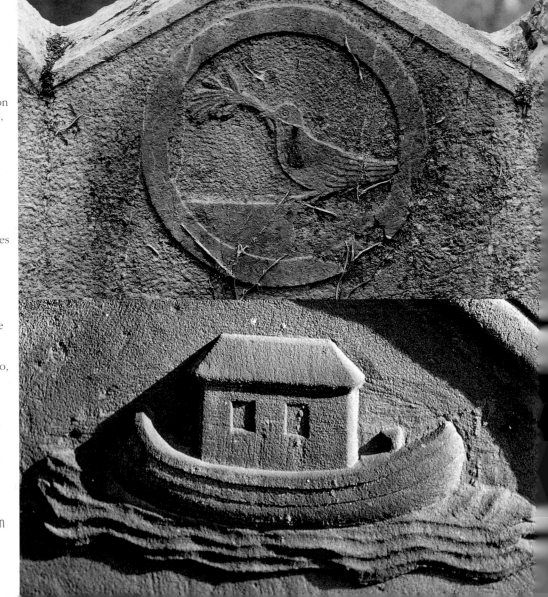

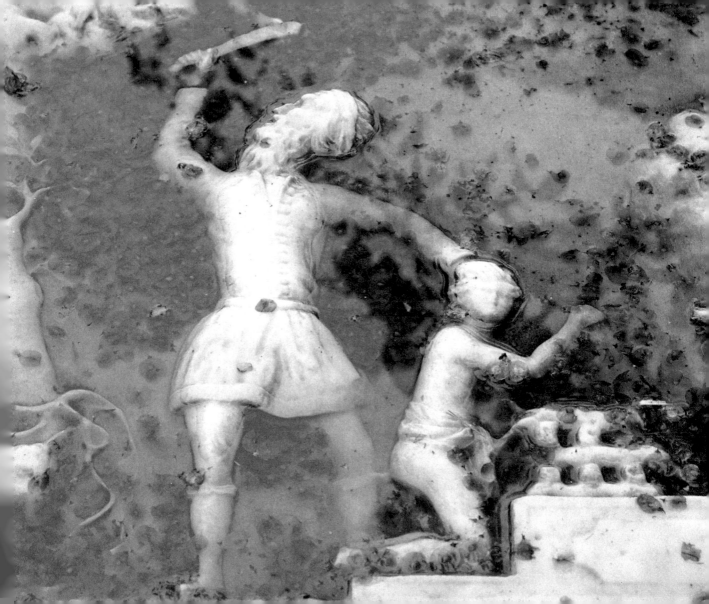

[He] arrayed Mordechai and paraded him through the city square....
ESTHER 6:11

Right:
This detail from the tomb of Moses de Mordechai depicts Mordechai, the biblical hero of the Purim (Feast of Lots) story. Here he appears on horseback, flanked by Jacob's sons Benjamin, on Mordechai's right, and Judah, on his left. The Hebrew inscription above the riverside entrance to the cemetery reads: "I will open your graves, and cause you to come up out of your graves, O My people; and I will bring you into the land of Israel." 5490 (1730), Ouderkerk, Netherlands

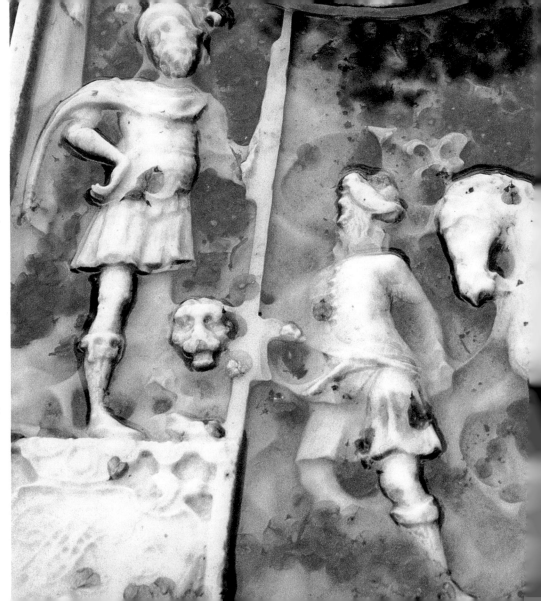

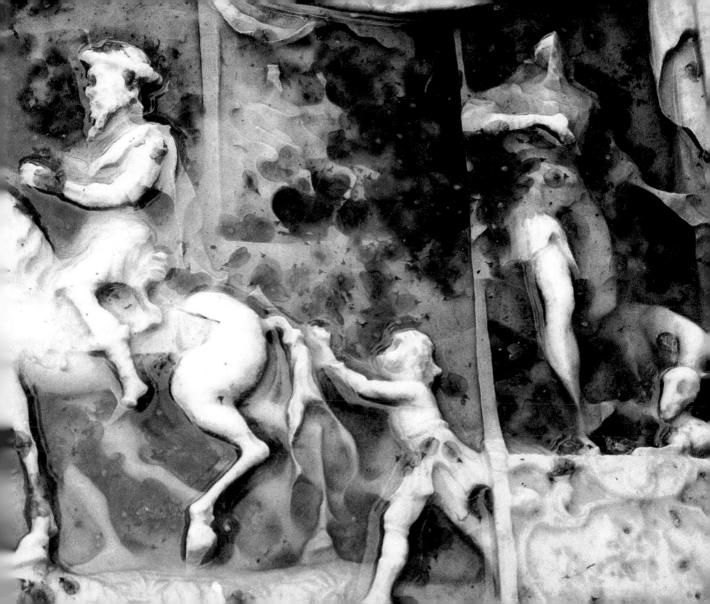

'Rachel died, to my sorrow...and I buried her there on the road to Ephrath'— now Bethlehem.

GENESIS 48:7

Top and bottom: Among the 200,000 gravestones in this cemetery are these two early-19th-century memorials depicting shepherdless sheep, perhaps alluding to the orphaned state of the bereaved. Gesia Cemetery, Warsaw

Opposite: This scene on the tomb of Rachel Vega, 5455 (1695), depicts the encounter of Rachel and Jacob at the well. Ouderkerk, Netherlands

38

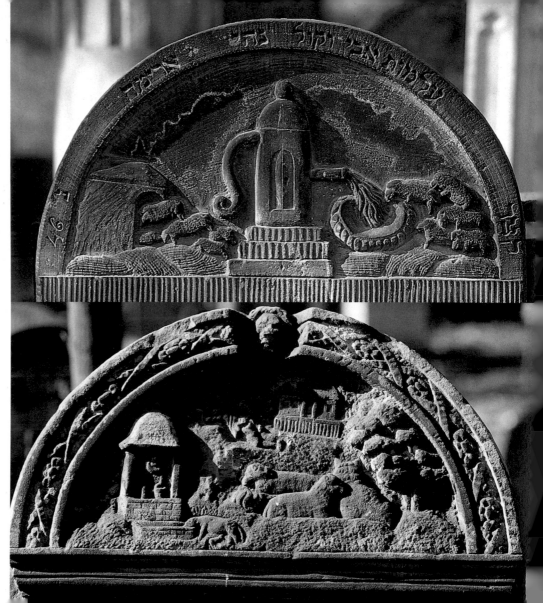

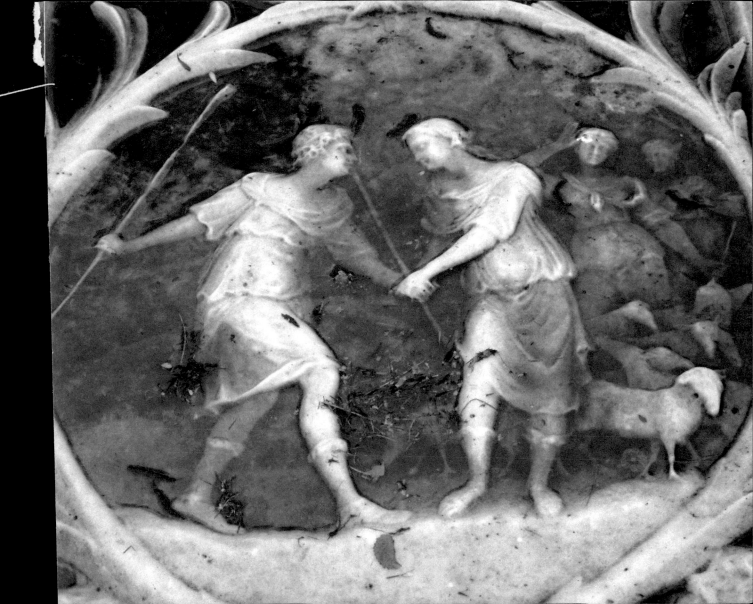

*Its seven lamps...
mounted as to give
the light...*
EXODUS 25:37

The woman of the house traditionally lights candles on the eve of the Sabbath; thus the candelabrum has become a symbol for a righteous woman. As the seven-branched menorah was revered as a symbol of the Temple, it was forbidden to reproduce this configuration on memorials; however, sometimes this prohibition was ignored. The candelabrum was also believed to be an apotropaic symbol used to frighten away grave robbers.

Right:
Guru Humorului, Romania

Opposite:
Szydlowiec, Poland

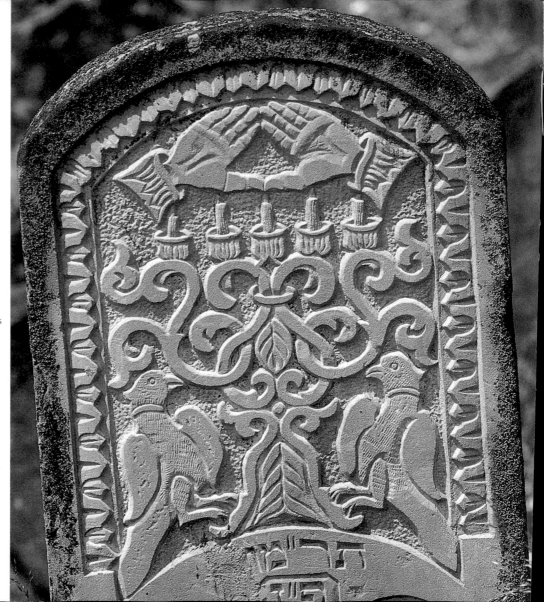

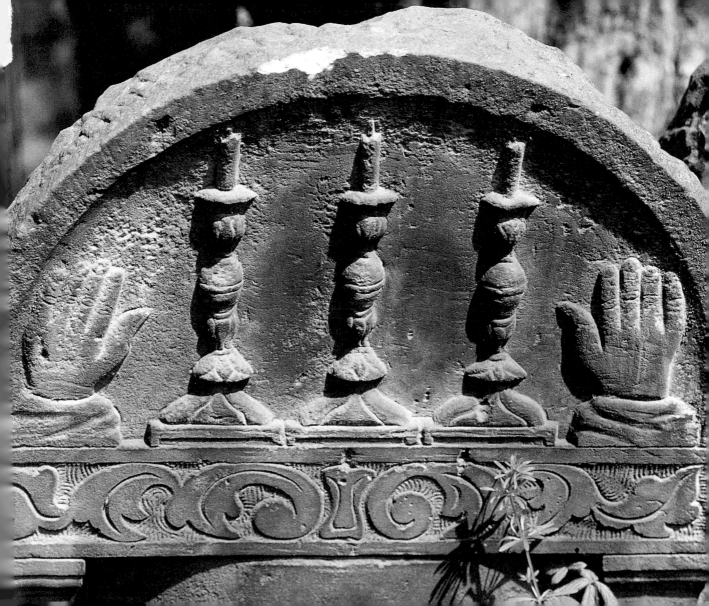

You shall make a lampstand of pure gold.
EXODUS 25:31

Right:
Five-branched candelabrum. Fălticeni, Romania

Opposite:
A candelabrum on the mausoleum of the Goldschmiedt family. Their descendants wished to ship the huge mausoleum to the United States but were prevented by the Italian Ministry of Monuments and the Jewish community. Cimitero Nuovo, Lido, Venice

Page 44:
Seven-branched candelabra. Guru Humorului, Romania

Page 45:
Broken candles represent the loss of a woman. Checiny, Poland

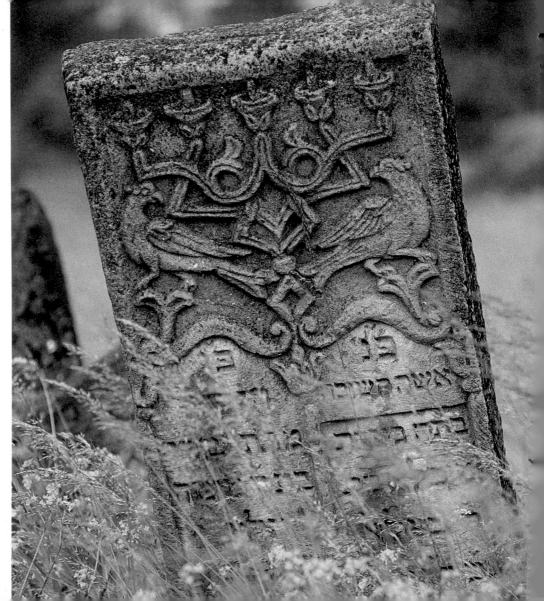

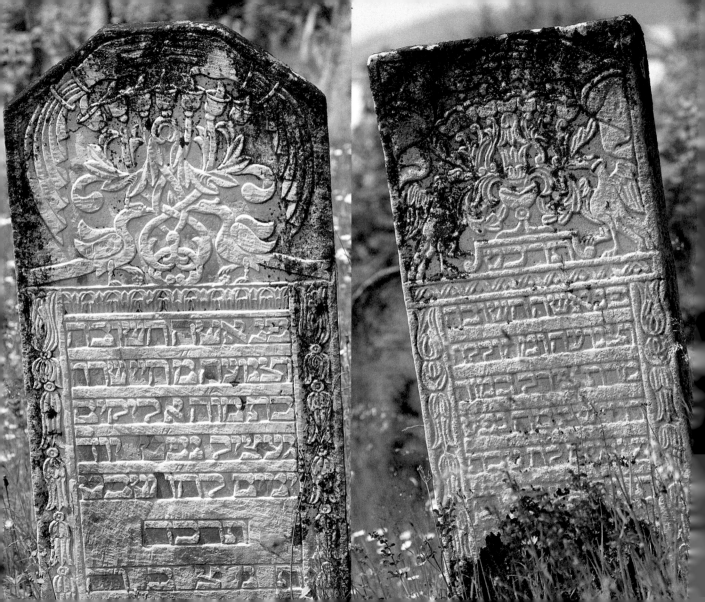

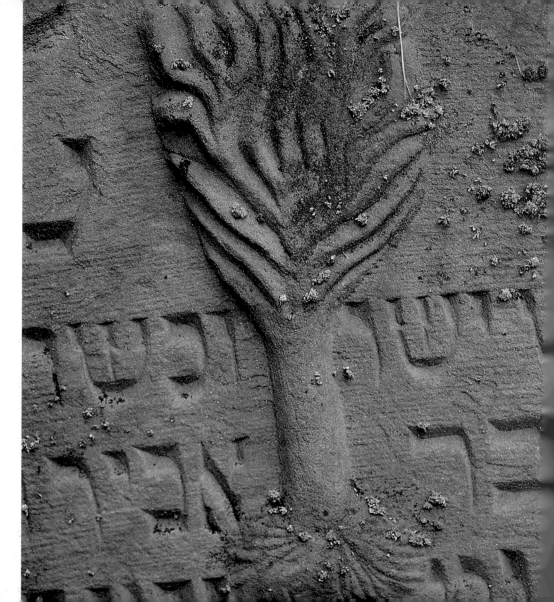

[Wisdom] is the tree of life.
PROVERBS 3:18

Right:
Etz chayim (the tree of life), a symbol of the Torah. 16th century, Unterbalbach, Germany

Opposite:
A detail from an 18th-century Sephardic monument shows heavenly hands wielding an ax to fell the tree of life, symbolizing a flourishing life cut short. Other such devices are a broken bridge and a broken ship's mast. Ouderkerk, Netherlands

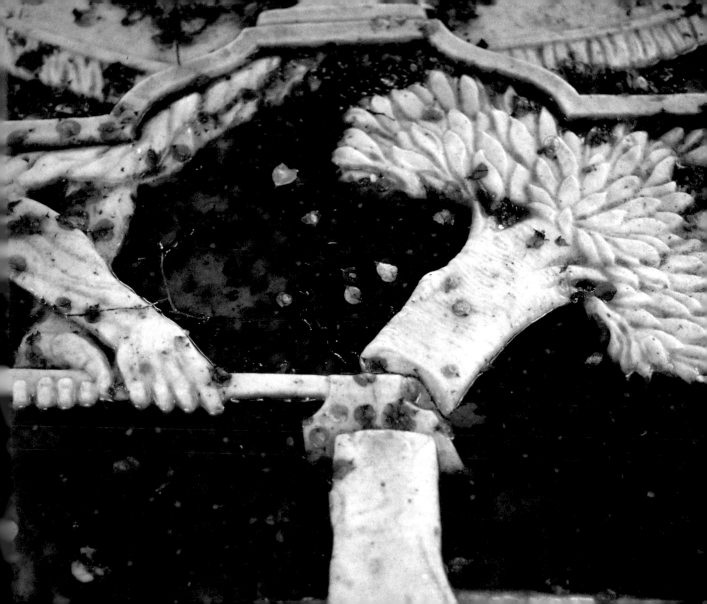

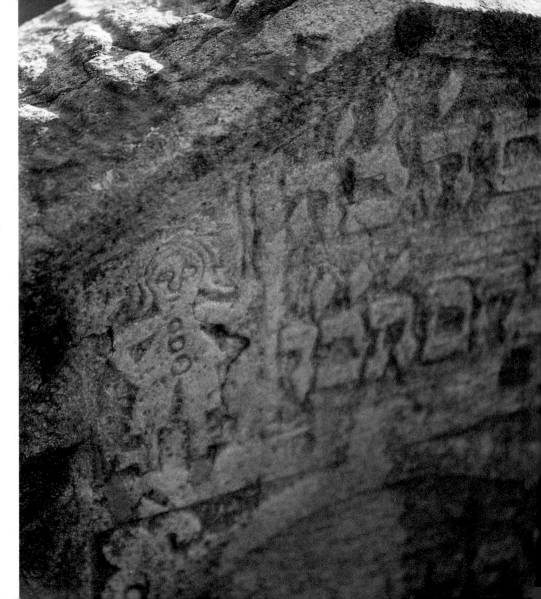

O youth, enjoy yourself while you are young!
ECCLESIASTES 11:9

These Gothic pointed-gable headstones made from Slovenic marble and quartz sandstone are two of approximately twelve thousand stones in this cemetery. To cope with insufficient space, over the centuries, graves were dug one on top of the other, sometimes twelve layers deep. The oldest stone (not pictured) is dated 1439. Old Jewish Cemetery, Prague

Right:
A young boy. Old Jewish Cemetery, Prague

Opposite:
A virgin. Old Jewish Cemetery, Prague

48

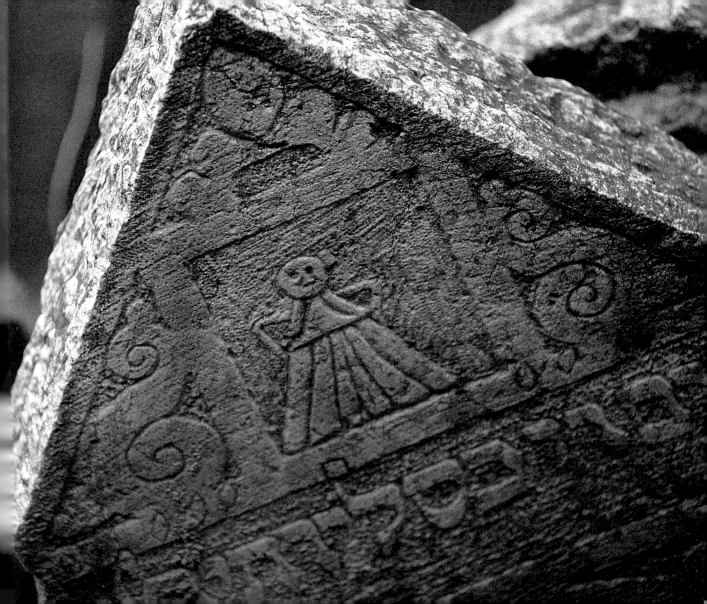

Happy is he who is thoughtful of the wretched....
PSALMS 41:2

Tzedakah (charity) is an important precept of Jewish life. The alms box is a symbol for a philanthropist or a *gabbai* (the temple official who collects dues and contributions).

Above:
Alms box.
Cimitero Nuovo,
Lido, Venice

Right and opposite:
A hand places
money in an
alms box.
Gesia Cemetery,
Warsaw

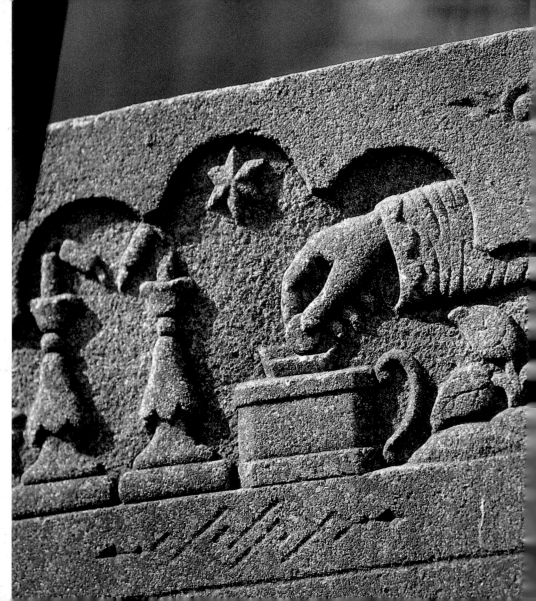

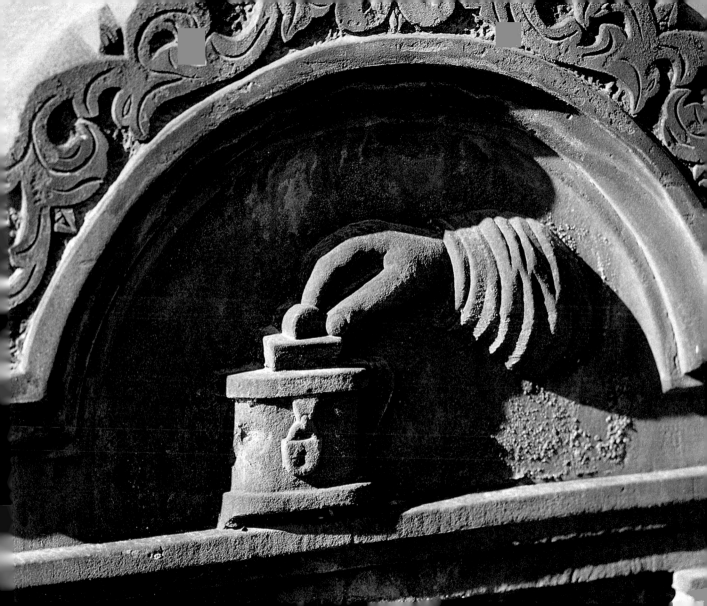

*Wealth and riches
are in his house....*
PSALMS 112:3

Right:
Opulent
mausoleums in
Budapest, Hungary,
attest to a once-
affluent community.
The ceramic
and mosaic
Art Nouveau
mausoleum of
Schmidl Sándor
Csalådja, 1899.

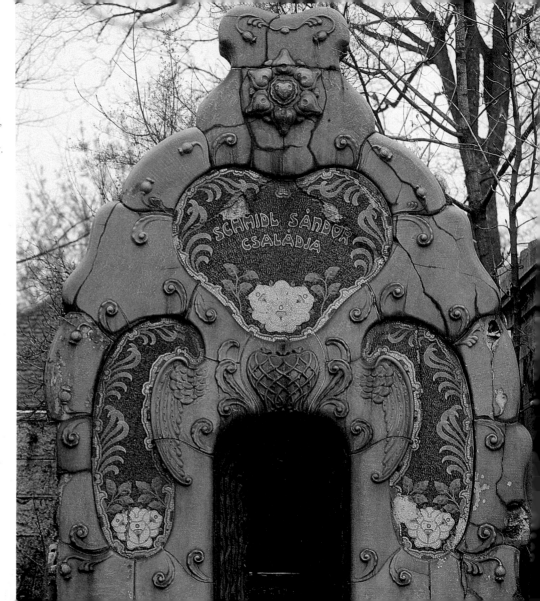

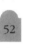

Above:
Mosaic interior of
the mausoleum.

Opposite:
A half-scale 1948
automobile
adorns a unique
mazzevah
(raised stone),
memorializing
Kunstadter
Vilmosne.
Budapest

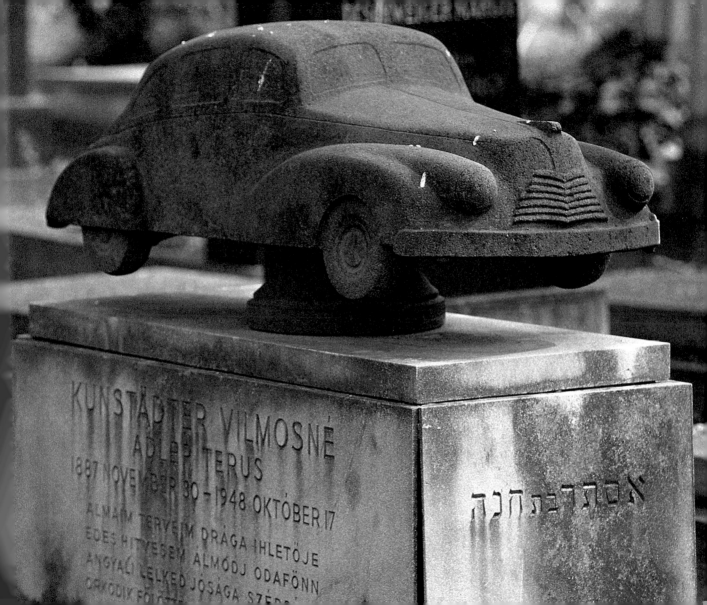

KUNSTÄDTER VILMOSNÉ
ADLER TERUS
1887 NOVEMBER 30 - 1948 OKTÓBER 17
ÁLMAIM TERVEIM DRÁGA IHLETŐJE
ÉDES HITVESEM ÁLMODJ ODAFÖNN
ANGYALI LELKED JÓSÁGA SZÉP...
ŐRKÖDIK FÖLÖTTE...

אסתר בת חנה

54

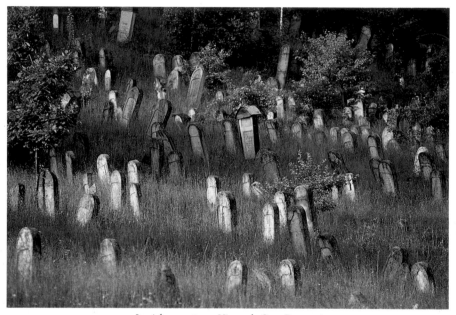

Jewish cemetery. Viseu de Sus, Romania

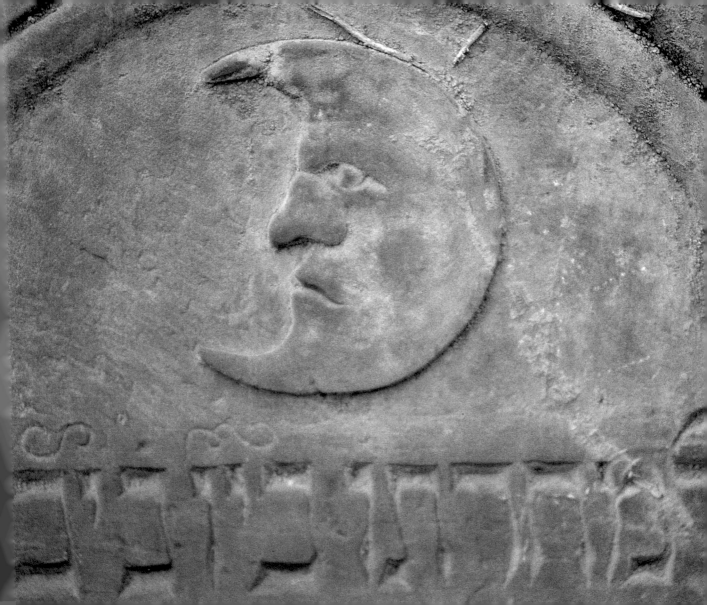

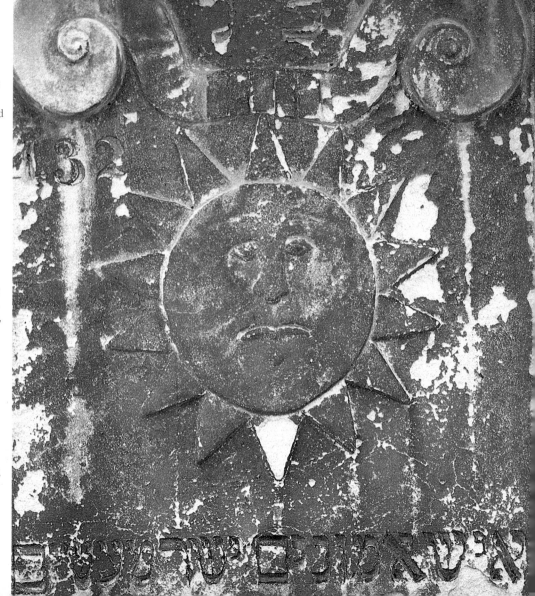

*I created in pairs,
heaven and earth
a pair, sun and
moon a pair.*
SONG OF SONGS RABBAH

The sun and the
moon are associated
with the Kabbalah
(Jewish mysticism)
and astrology.

Page 55:
A moon.
Frankfurt am Main

Right:
A sun motif.
Weikersheim,
Germany

Opposite, left:
Stone for a member
of the Habib family.
San Nicolo del Lido,
Venice

Opposite, right:
The sun motif
also represents the
members of the
Hevra Kaddisha
(a sacred charitable
society) who are
responsible for the
burial of the dead.
San Nicolo del Lido,
Venice

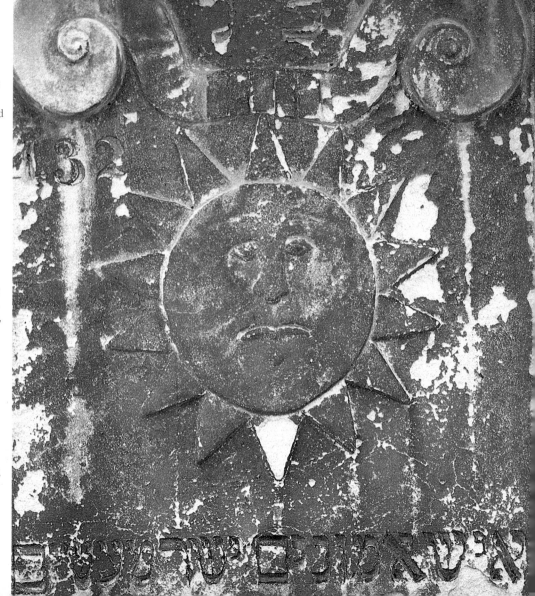

56

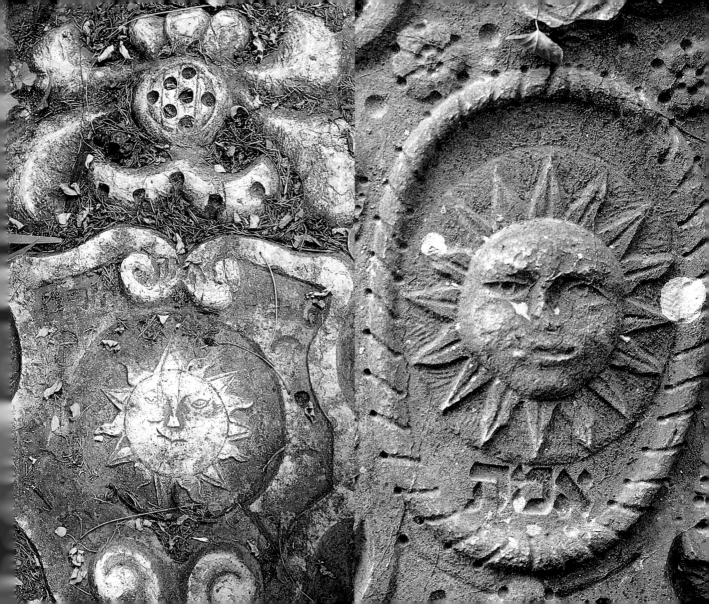

And Solomon sat upon the throne of his father David....
1 KINGS 2:12

Right:
The "knot of Solomon" is a Kabbalistic device of divine inscrutability. The "seal of Solomon" is another name for the ancient motif known as the Magen David (Star of David). It appears today on the flag of the State of Israel.

Opposite:
San Nicolo del Lido, Venice

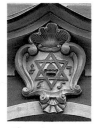

Above:
Star of David. Jewish Town Hall, Prague

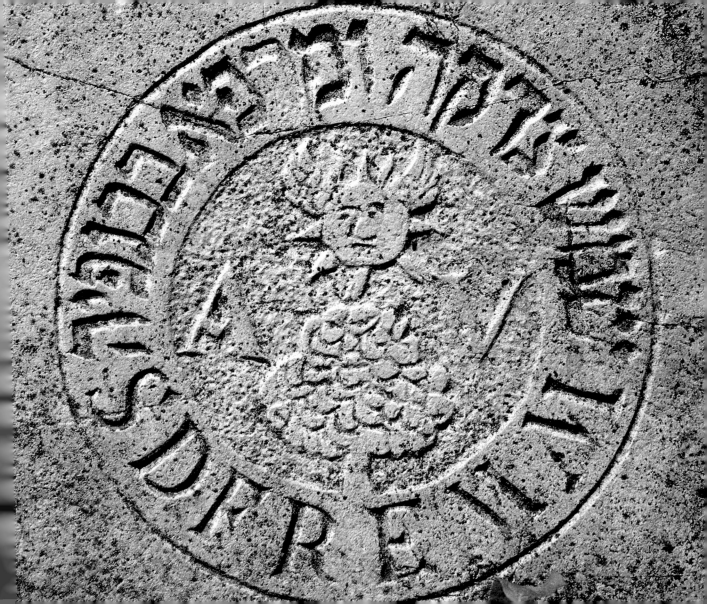

*For He will order His
angels to guard you
wherever you go.*
PSALMS 91:11

Angels and cherubs
are not usually
identified with the
Jewish religion,
but they appear
frequently on
Sephardic
memorials.

Right:
Winged cherub,
5461 (1701).
Velho Cemetery,
London

*Opposite,
left, top:*
A bird of prey
transports the
deceased to heaven.
San Nicolo del Lido,
Venice

*Opposite,
left, bottom and
right, top:*
Pappenheim,
Germany

*Opposite,
right, bottom:*
Winged angel.
Old Jewish
Cemetery, Prague

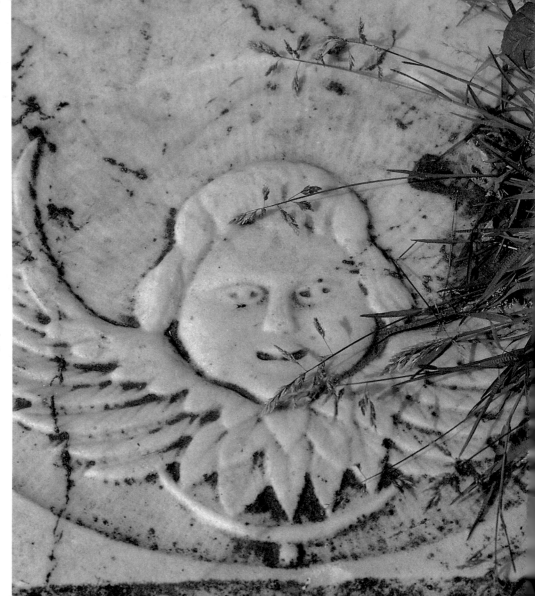

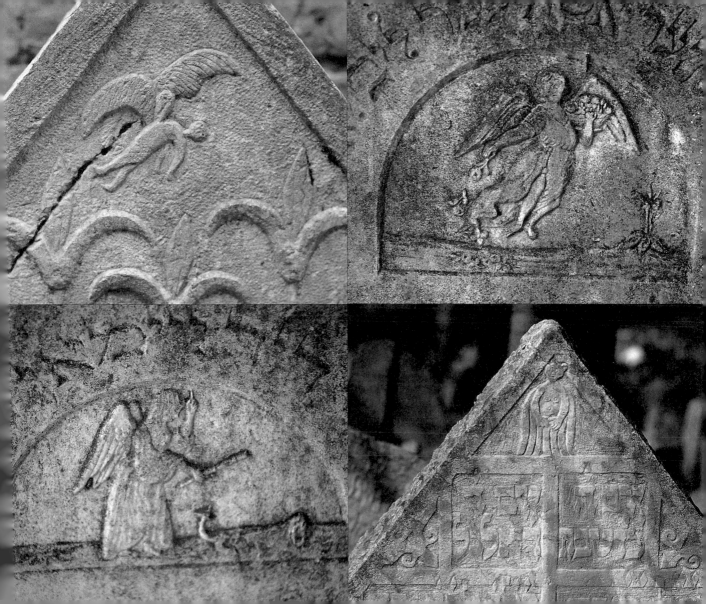

This one at last is bone of my bones and flesh of my flesh.
GENESIS 2:23

The skeleton and Death's head, images traditionally used by non-Jews, are frequently found on memorials in Spanish and Portuguese Sephardic communities. Usually inscribed in Hebrew and Ladino (a Judeo-Spanish language), Sephardic gravestones are horizontal, unlike the conventional vertical *mazzevot* of the Ashkenazi of northern Europe.

Right and opposite: Ouderkerk, Netherlands

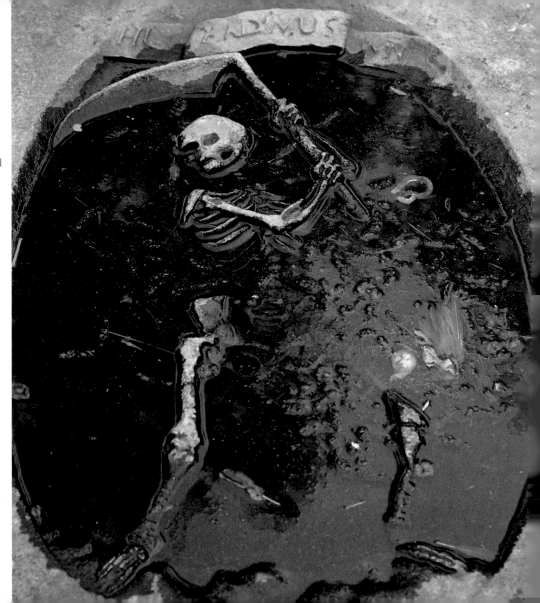

You shall be buried at a ripe old age.
GENESIS 15:15

A detail from the tomb of Benjamin 5505 (1744) and Rivka Teixeira 5515 (1755). Ouderkerk, Netherlands

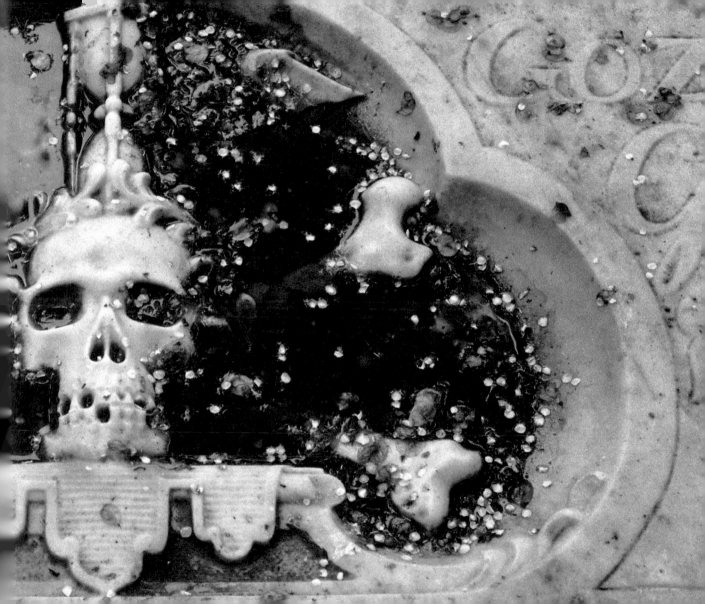

66

Gesia Cemetery, Warsaw, Poland

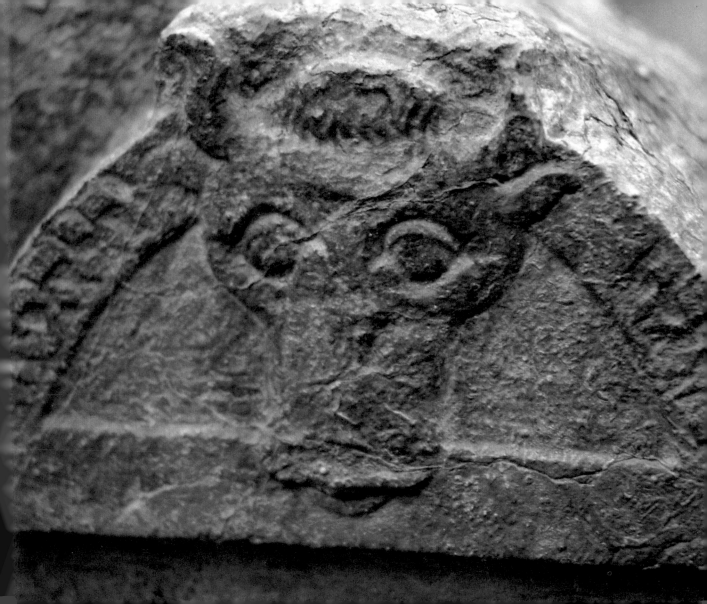

Your ox shall be slaughtered before your eyes....
DEUTERONOMY 28:31

The *shor ha-bar* (wild ox) is a messianic beast thought to have supernatural powers and considered to be a delicacy the righteous will feed upon at the mystical banquet at the end of the world. The ox is also the symbol of the tribes of Ephraim and Menasheh.

Page 67:
Ox head.
Old Jewish
Cemetery, Prague

Right:
Wild ox.
Worms, Germany

Opposite:
An ox, its hooves trussed, ready for the ritual slaughter, on the *mazzevah* of a ritual slaughterer. Fălticeni, Romania

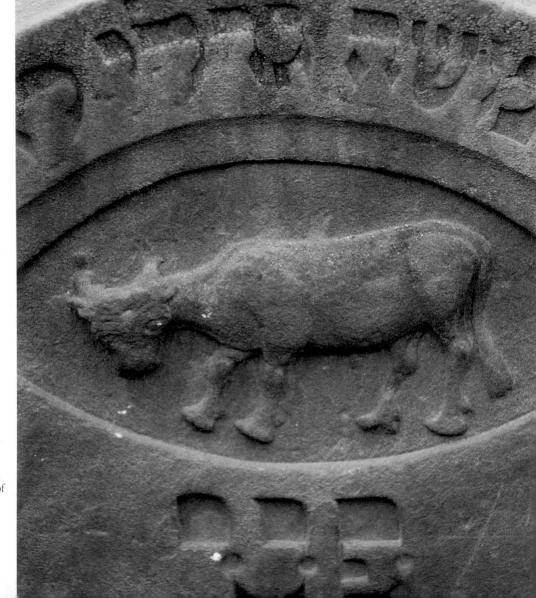

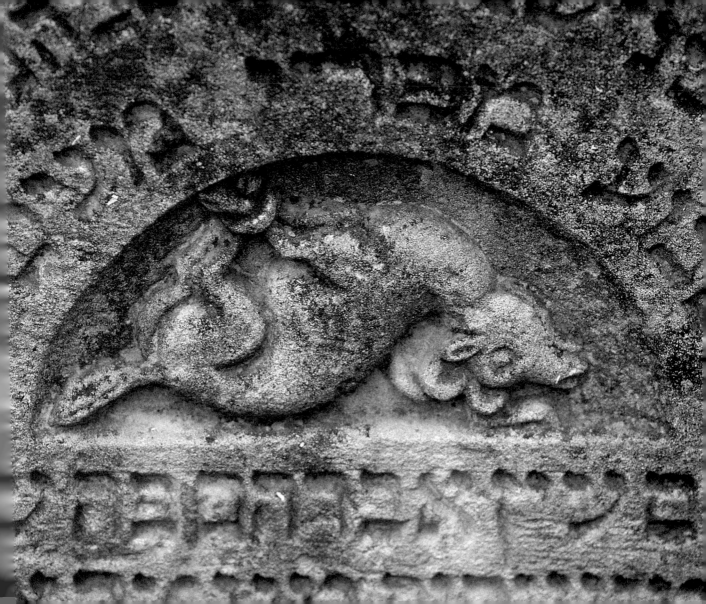

His father is of Judah and his mother of Dan and together they are called lion.
YALKUT SHIMONI
GENESIS 160

Revered as the king of beasts, the lion has always been a symbol of triumph and was adopted by several of the tribes of Israel, including Dan, Gad, and Judah. The lion is the insignia of people named Yehuda, Leib, Lebb, or Ari.

Right:
Rampant lion and moon. Georgensgmünd, Germany

Opposite:
Rampant lions support a tree of life. Unterbalbach, Germany

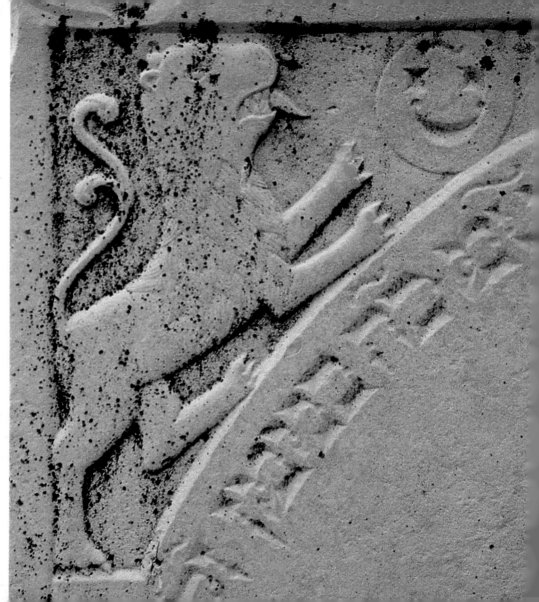

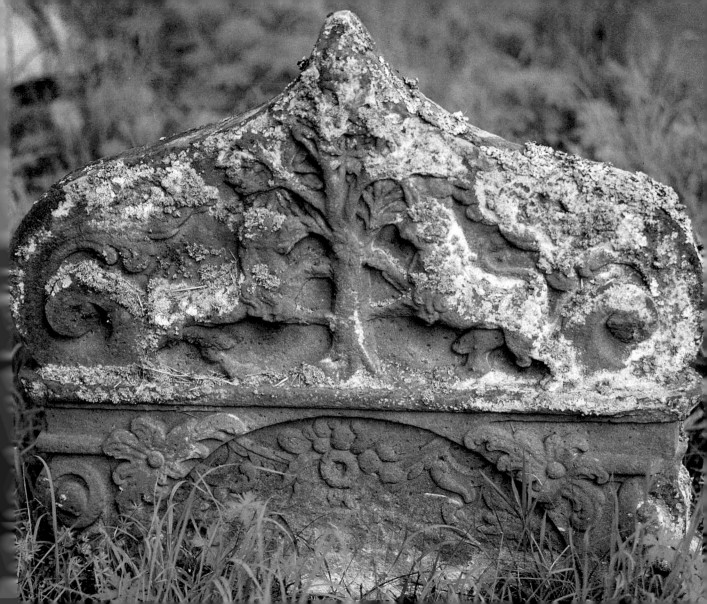

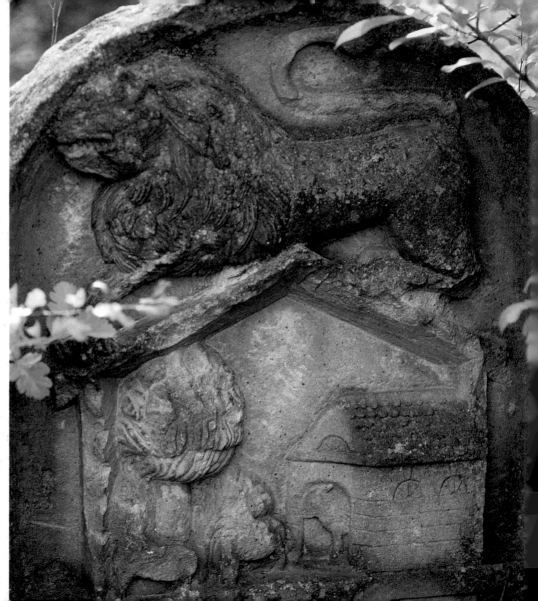

Strong as a tiger,
light as an eagle,
swift as a deer,
bold as a lion.
ETHICS OF THE FATHERS

Right:
Lion and sheep.
Mszczonów, Poland

Opposite, left:
Rampant lions.
5591 (1831),
Mszczonów, Poland

Opposite, right:
A lion and a serpent
in the round.
Vestre Kirkgårds
Alle, Copenhagen,
Denmark

Page 74
Left, top:
Unterbalbach,
Germany

Left, bottom, and
right, top:
Guru Humorului,
Romania

Right, bottom:
Wachock, Poland

Page 75:
A winged lion.
Old Jewish
Cemetery, Prague

72

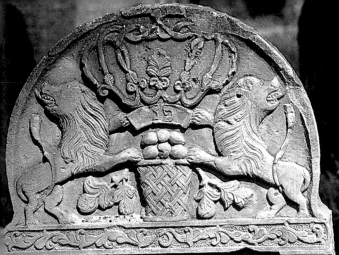

מנשה והחשובה
הצנועה בפה פרשה
לעני וידיה שלחה
לאביון מרת בייל'
עזבלת מלקוחני
ולמן עטרה הבים ר
הו מהב שנתל
צי תתצב

אנש כחציר ימיו כציץ השדה
כן יציץ וחסד י מעולם
ועד עולם על יראיו

וצדקתו לבני
בנים

Left to right:
1. Warsaw
2. Kraków
3. Warsaw

1. Warsaw
2. Warsaw
3. Georgensgmünd

1. Michalovce
2. Venice
3. Frankfurt
 am Main

1. Kraków
2. Prague
3. Szydlowiec

Opposite:
Couchant lion,
Szydlowiec, Poland

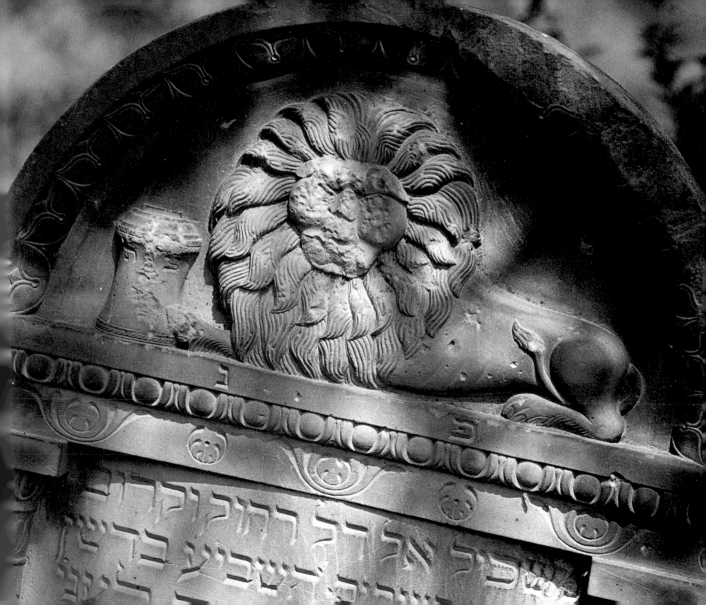

And the frogs came up and covered the land....
EXODUS 8:2

Top:
A frog (referring to one of the ten plagues visited upon the Egyptians) on a red sandstone *mazzevah.*
Frankfurt am Main

Bottom:
This monkey is part of the messianic bestiary in the Battonstrasse Cemetery.
Frankfurt am Main

Opposite:
Creatures like the baroque beast decorating this tomb often allude to the coming of the Messiah.
Cimitero Nuovo, Lido, Venice

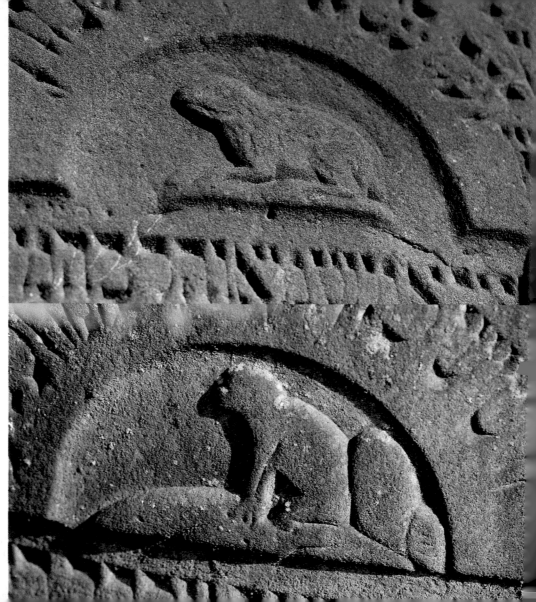

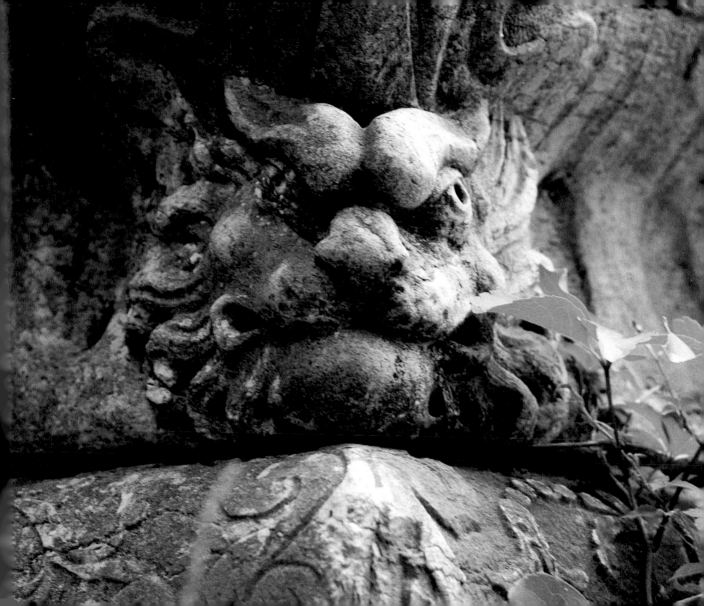

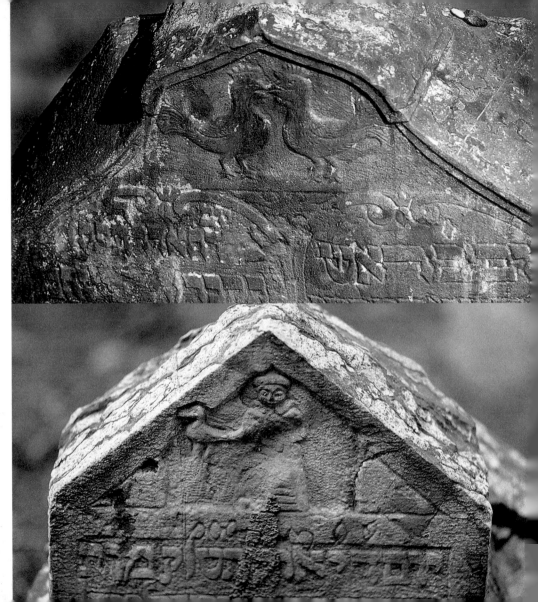

The time of pruning has come; the song of the turtledove is heard in our land.
SONG OF SONGS 2:12

Top:
A pair of birds. A bird represents the Yiddish names Fegel and Kohut (Bird), and Hahn and Hähneles (Hen).
Old Jewish Cemetery, Prague

Bottom:
A woman holding a goose suggests the family name Gans (Goose).
Old Jewish Cemetery, Prague

Opposite:
The bear in search of "the sweetness of the Torah" is the messianic motif used for those named Ber or Dov (Bear).
The *mazzevah* of Ber Teller 5448 (1688).
Old Jewish Cemetery, Prague

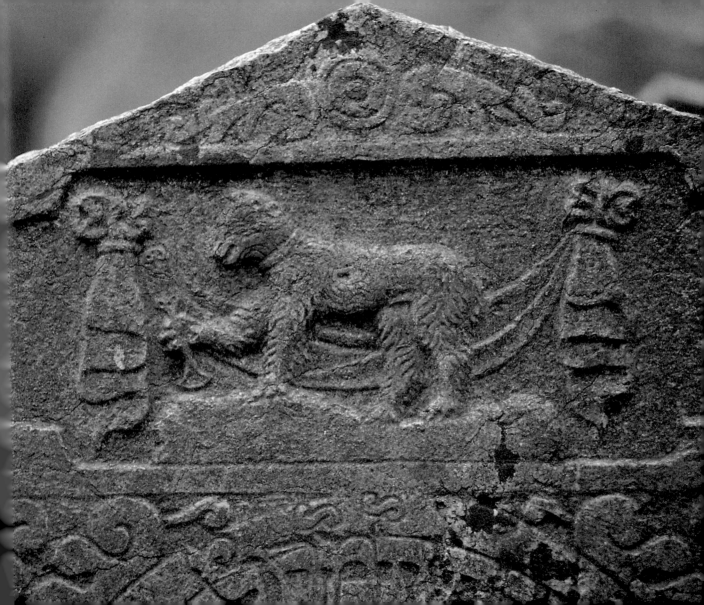

Who are his fledglings? They are the Jewish people....
TIKUNEI ZOHAR

Right:
An eagle suckles her young, symbolizing maternal love and sacrifice, over an alms box and an inkwell and quill, implements of a *sofer* (scribe). Gesia Cemetery, Warsaw

Opposite:
An eagle, an emblem of divine protection and immortality, surmounts a *sukkah*, a shelter that Jews are commanded to live in for seven days during the festival of Sukkot, to recall the plight of the Israelites during their exodus from Egypt. The *sukkah* is a symbol of the tribe of Reuben. Gesia Cemetery, Warsaw

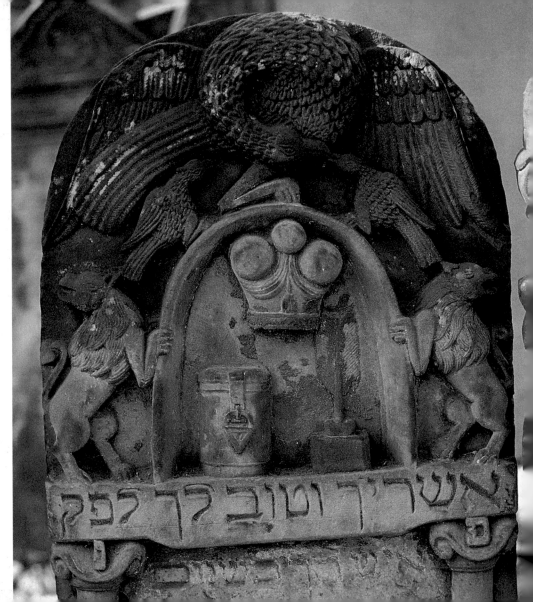

אשריך וטוב לך לפ"ק

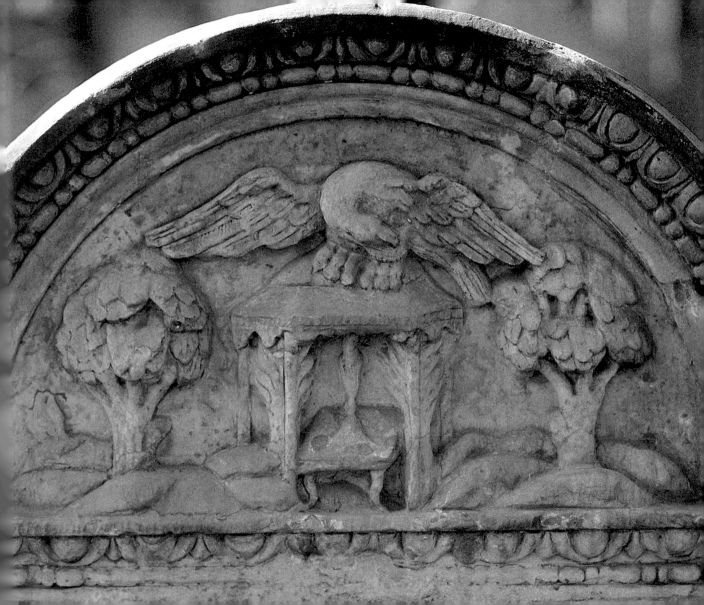

*But I will flog you
with scorpions.*
1 KINGS 12:11

Right:
The scorpion, a
sign of the zodiac.
A similar image
appears on the
5th-century mosaic
floor of the Bet Alfa
synagogue, Israel.
San Nicolo del Lido,
Venice

Opposite:
A curious cat,
representing the
family name Katz,
is all that remains
visible above
the ground.
Old Jewish
Cemetery, Prague

84

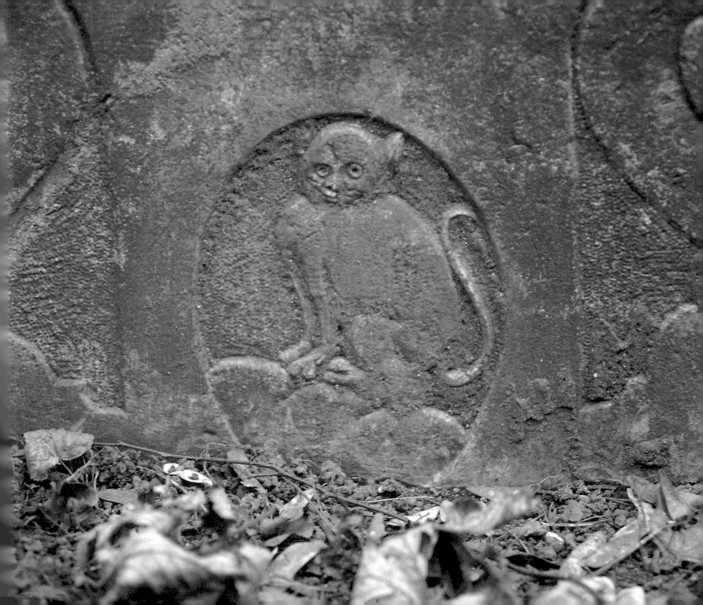

The wolf shall dwell with the lamb....
ISAIAH 11:6

Images of a single lamb represent the death of a young child. In Jewish cemeteries in New York, the lamb appears frequently on stones erected for the many children who died in the 1917 influenza epidemic. An image of a ram is a pictogram for people named Lamm or Lampel.

Top and bottom: These examples are in the Rossauer Cemetery, founded in 1582. Vienna, Austria

Opposite: A wolf represents the tribe of Benjamin and the name Ze'ev. Old Jewish Cemetery, Prague

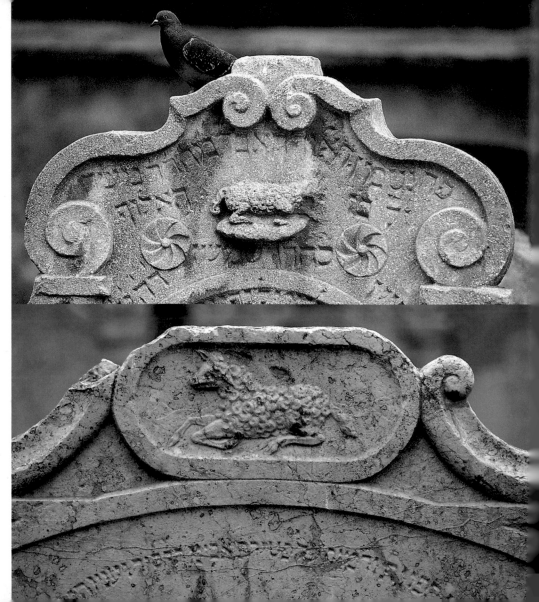

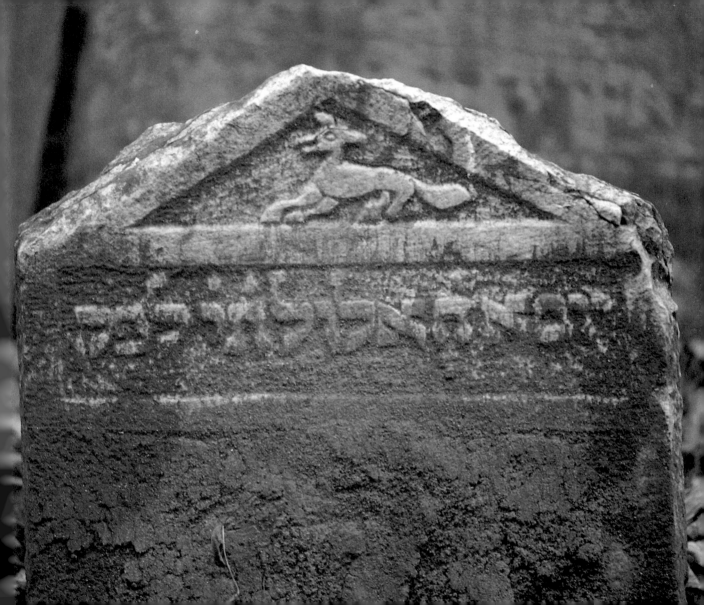

*Like the dragon
in the seas...*
EZEKIEL 32:2

Mythical beasts such
as the dragon and
griffin are
considered
messianic creatures.

Right:
A pair of
rampant griffins.
In this region of
Romania,
gravestones were
constructed to the
approximate height
of the deceased.
Fălticeni, Romania

Opposite:
A dragon,
representing the
family name Drach.
Frankfurt am Main

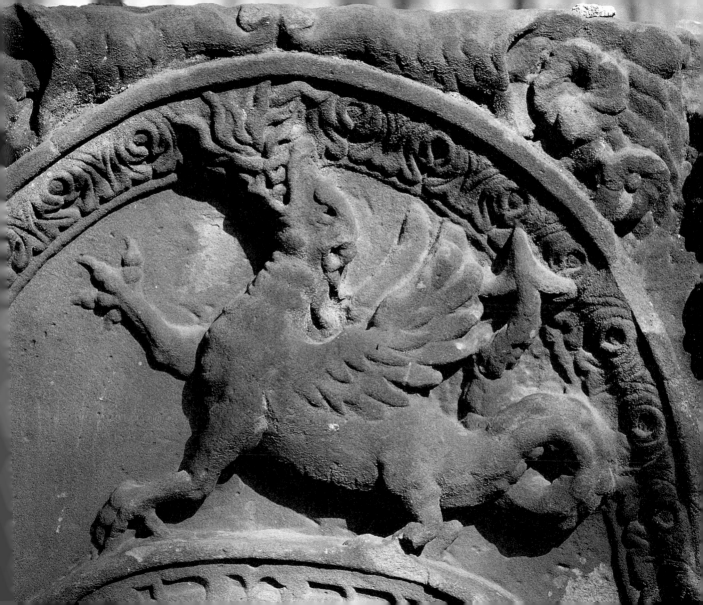

Dan shall be a serpent by the road....
GENESIS 49:17

Right:
Among the 360 monuments in this cemetery that survived the Nazi holocaust is this one featuring a serpent, which represents the tribe of Dan. Rema Cemetery, Kraków

Opposite:
A snake swallowing its own tail is a device suggesting infinity. The winged hourglass symbolizes transition. Gesia Cemetery, Warsaw

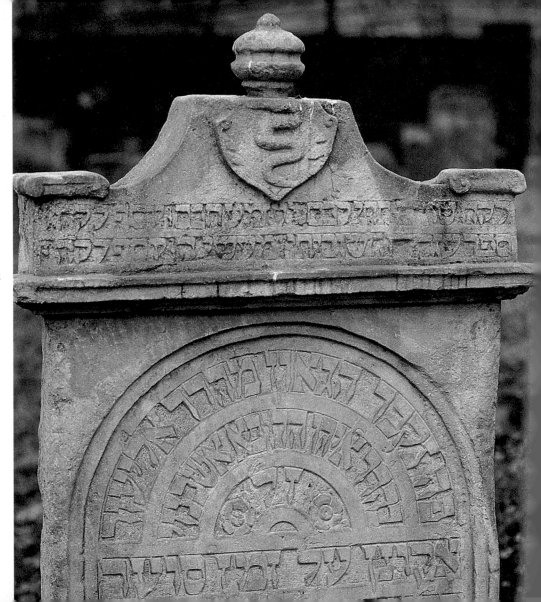

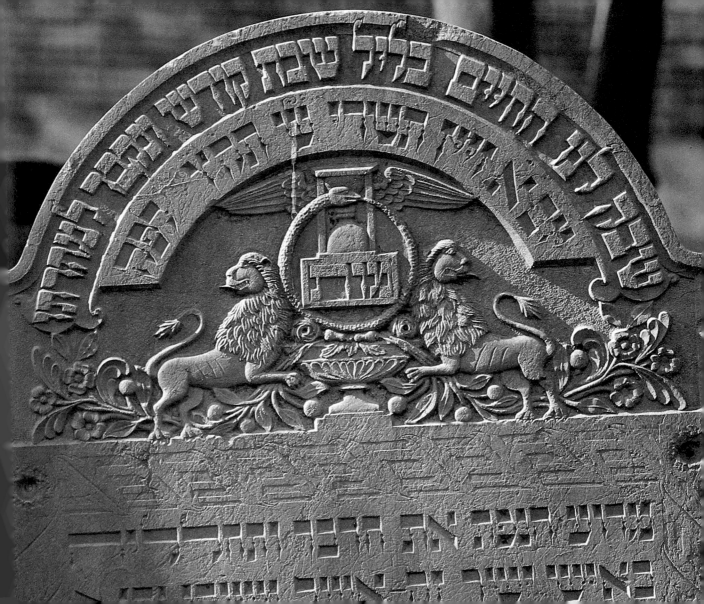

The stork has her home in the junipers.
PSALMS 104:17

A pair of storks. The stork is a sepulchral sign and a symbol of creation. A painting on the walls of the 16th-century synagogue in Mogilev, Belorussia, shows a flock of storks, representing Hasidim (members of a strict religious sect) flying to Jerusalem. The Hebrew word for stork is *hasidah*. The two Hebrew letters between the storks signify *poh nikbar* (here lies buried). Fălticeni, Romania

A hind let loose...
GENESIS 49:21

Right and opposite:
A deer is a
popular motif
representing the
names Naphtali,
Hirsh, and Zvi.
It also stands for
tranquility.
Unterbalbach,
Germany.

Page 96:
A deer, and a ewer
and laver of the
Levites.
Old Jewish
Cemetery, Prague

Page 97:
A running deer.
Gesia Cemetery,
Warsaw

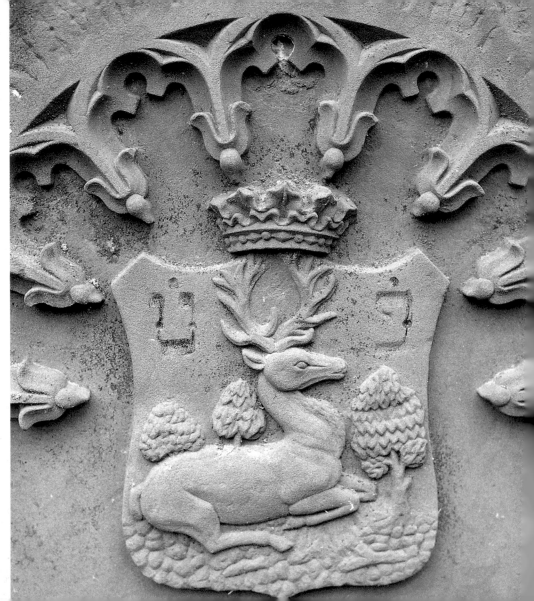

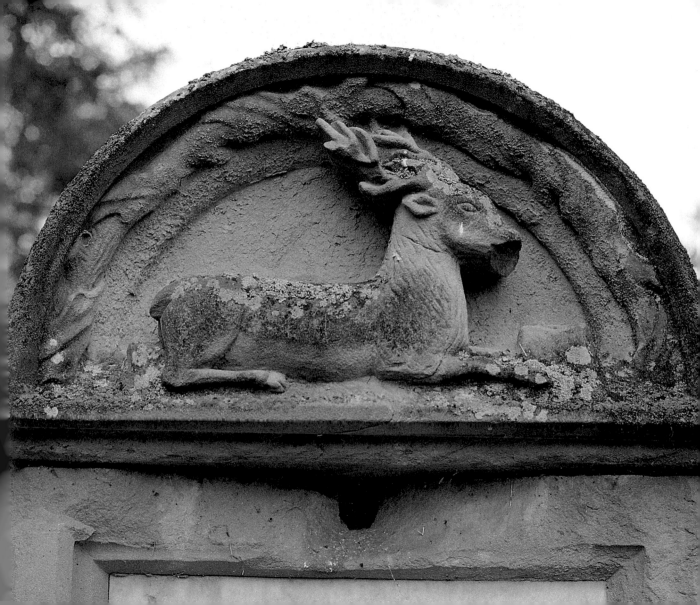

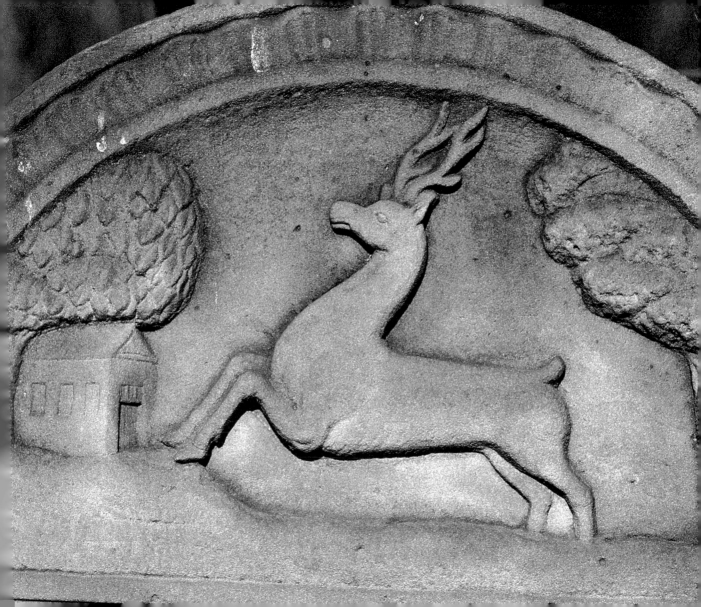

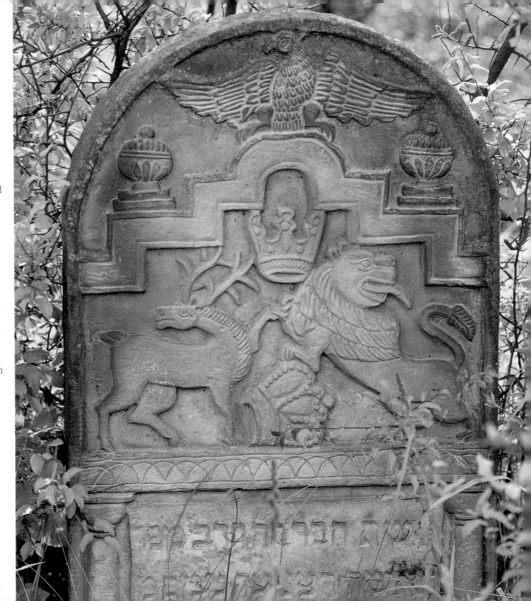

The crown has fallen from our head....
LAMENTATIONS 5:16

Right:
A deer and a lion stand over a fallen crown, representing the loss of the head of a family. Mszczonów, Poland

Opposite:
Old Jewish Cemetery, Prague

Page 100
Left, top:
Fallen deer.

Left, bottom:
A grapevine entwines a pair of stags.

Right:
A pair of Corinthian pilasters, representing the columns of the Temple, means stability. Gesia Cemetery, Warsaw

Page 101:
Tombstone of Rabbi Naphtali Hirsch. 1712, Worms, Germany

טמ ד הבה רבי
בדציון אלי

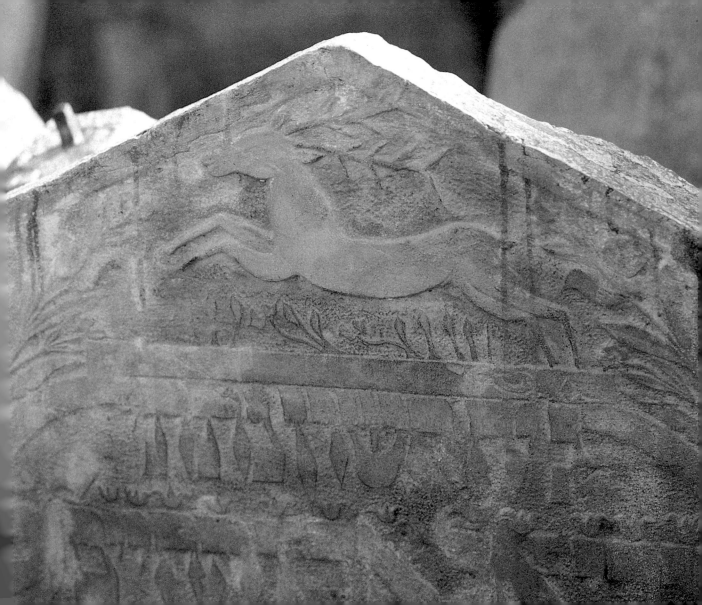

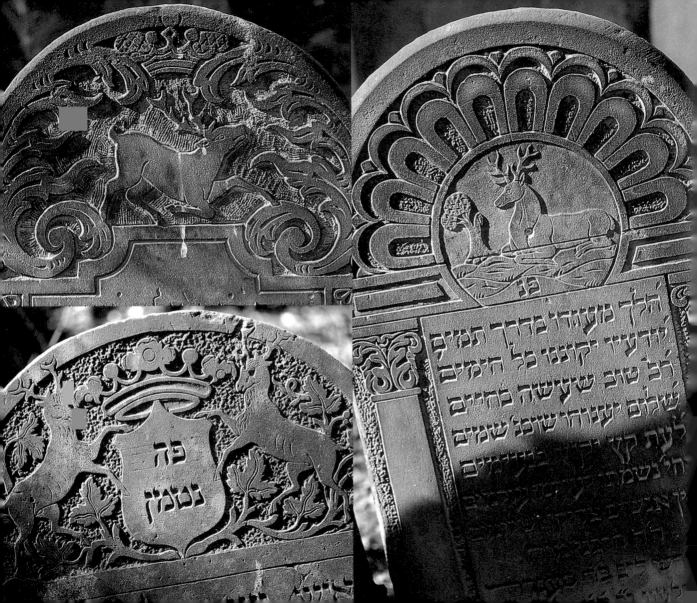

פה
נטמן

הלך מעודו בדרך תמים
יודעיו יקוננו על המר
רב טוב שעשה בחיים
שלום יענוח שוכן שמים

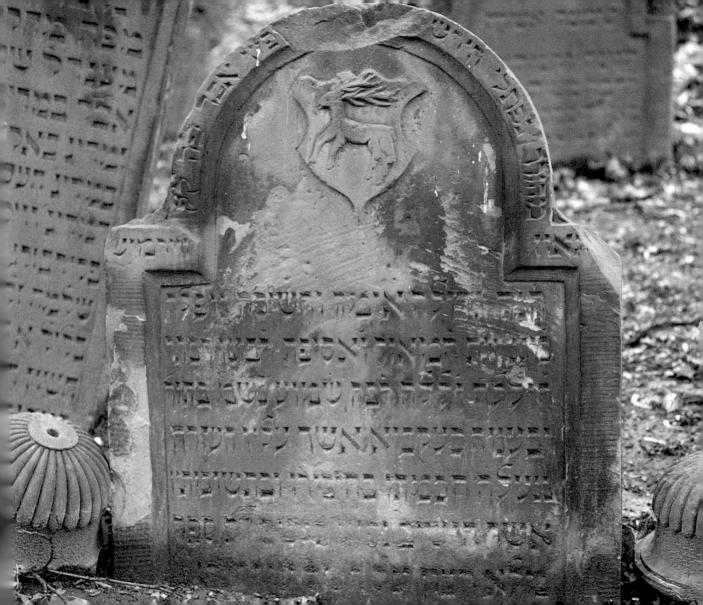

For a stone shall cry out from the wall....
HABAKKUK 2:11

Right:
The image of a deer is among the fragments of gravestones making up this wall constructed by non-Jewish students from 15th- and 16th-century memorials desecrated during World War II. Rema Cemetery, Kraków

102

The crown of the priesthood was taken by Aaron, the crown of kingship was taken by David, the crown of Torah remains for all generations to come.
ECCLESIASTES MIDRASH RABBAH 7

The crown is an oft-used symbol of piety, the law, or the head of the family.

Right:
A crown surmounts a hand placing money in an alms box.
Mszczonów, Poland

Opposite:
The *mazzevah* of the famous Rema (Rabbi Moses Isserles). An extract from his epitaph reads: "From Moses to Moses there has not been such a Moses in Israel," 5332 (1572).
Rema Cemetery, Kraków

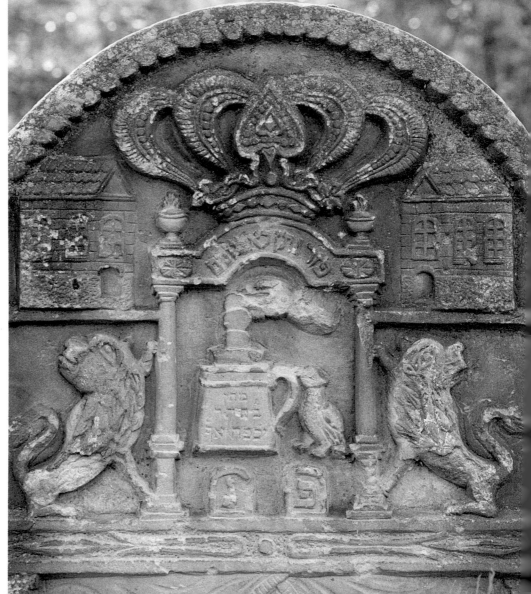

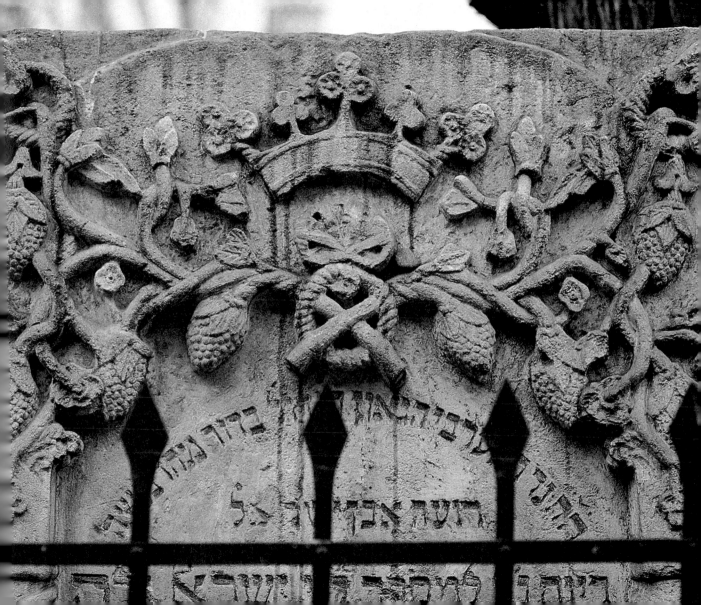

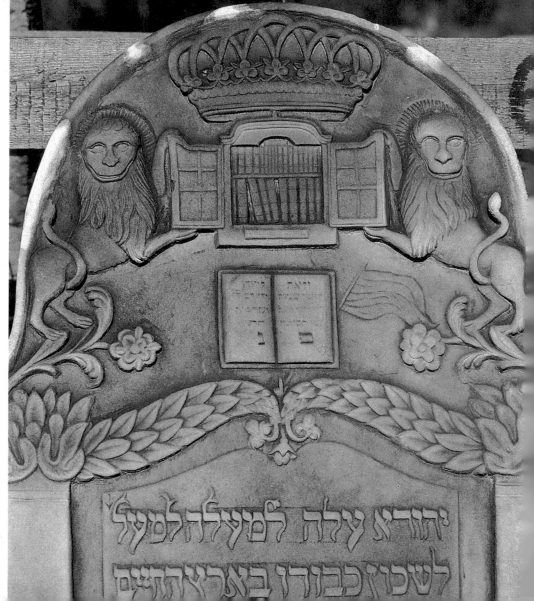

Let us fetch the Ark of the Covenant of the Lord from Shiloh....
1 SAMUEL 4:3

The Holy Ark frequently represents a man of knowledge, such as a rabbi, teacher, or scientist. These chests sometimes contain a Sefer Torah (Scroll of the Law), but more often display books.

Right:
Gesia Cemetery, Warsaw

Opposite:
Szydlowiec, Poland

Page 108
Top, left and right, and bottom right:
Szydlowiec, Poland

Bottom, left:
Gesia Cemetery, Warsaw

Page 109:
Dunes created by drifting sand from the Vistula River. Karczew, Poland

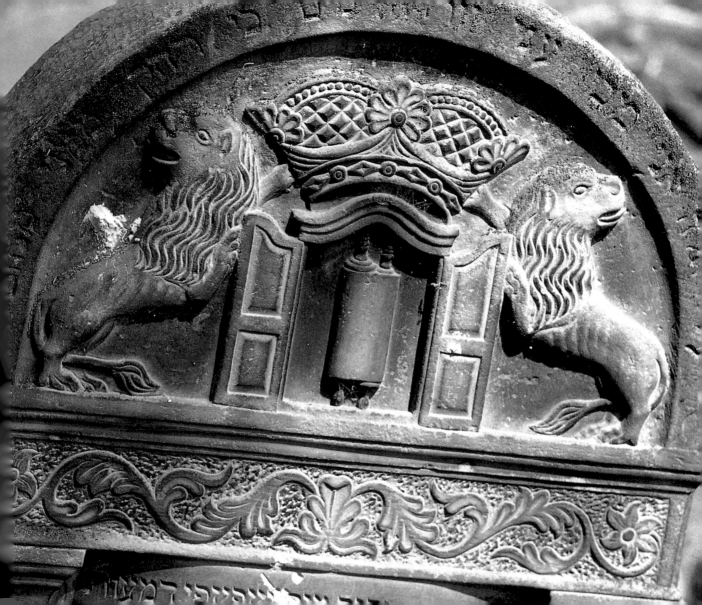

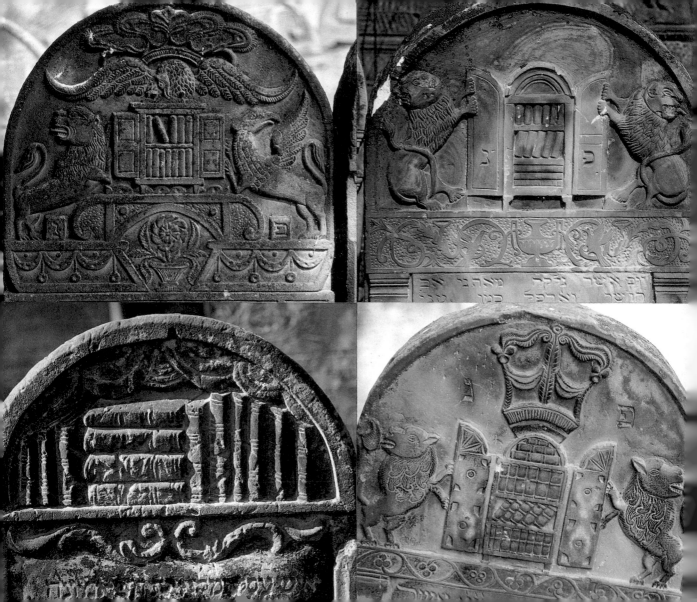

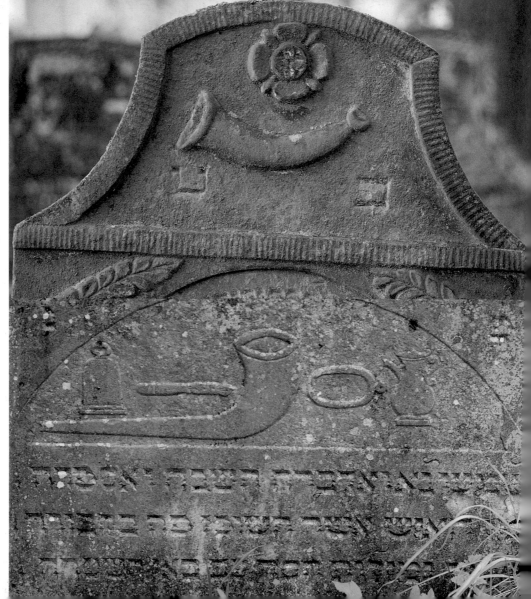

When the ram's horn sounds a long blast, they may go up on the mountain.
EXODUS 19:13

The *shofar* (ram's horn) is one of the earliest motifs found in the catacombs of Bet Shearim, Israel. The emblem is derived from the biblical story of the sacrifice of a ram instead of Isaac. It is also a messianic sign of resurrection associated with the prophet Elijah and the belief that he will sound a *tekiah gedolah* (great blast) prior to the arrival of the Messiah.

Top:
Weikersheim, Germany

Bottom:
Pappenheim, Germany

Opposite:
Treuchtlingen, Germany

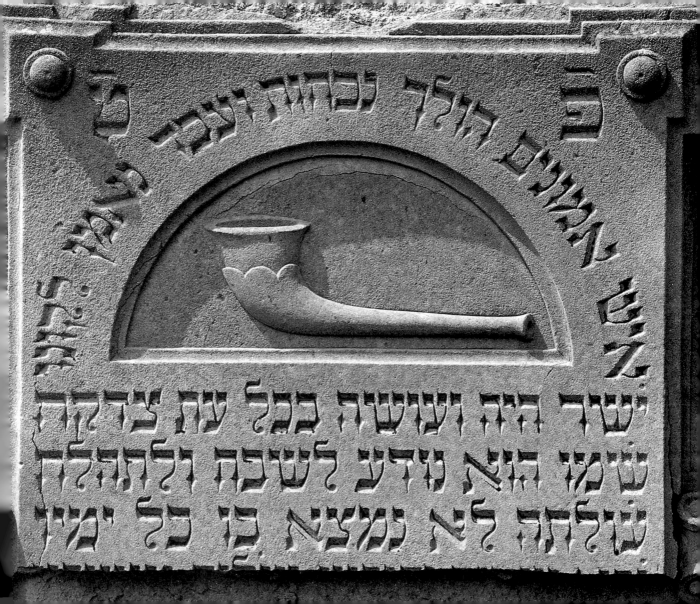

ויהי הולך נכוח וגם ט...
...אנשים וד...
...לאל ל...

שיר היה ועושה בכל עת צדקה
שמו הוא נודע לשבח ולתהלה
שלתה לא נמצא בו כל ימיו

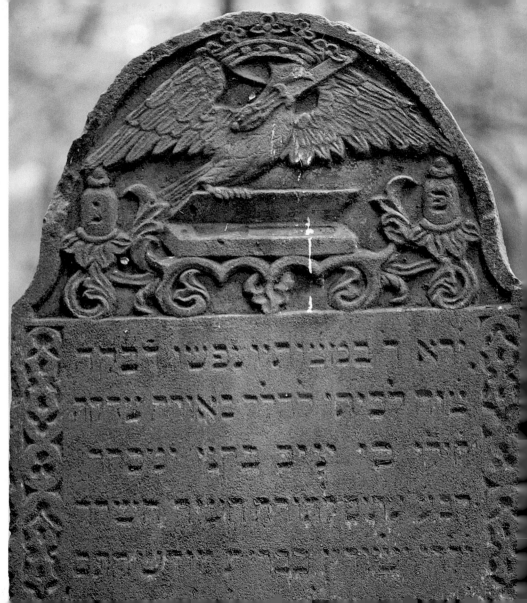

Every male among you shall be circumcised.
GENESIS 17:10

A *mohel* (a person qualified to perform ritual circumcisions) is held in high regard within the community.

Right:
An eagle holds a circumcision knife in its beak. Ulice Miodowa Cemetery, Kraków

Opposite:
A circumcision knife, a vial for powder or oil used in the ritual, and a deer (for the family name Hirsh). Another gravestone in this cemetery features a *mohel*'s protective shield. Georgensgmünd, Germany

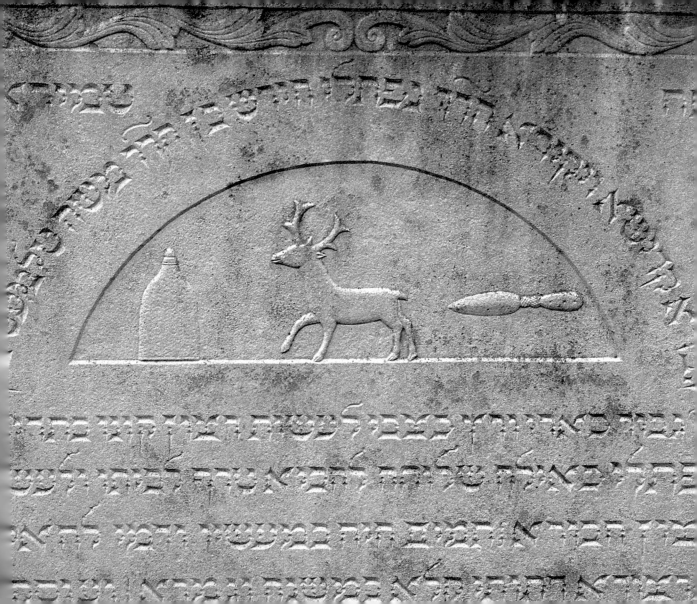

A good name is better than fragrant oil....
ECCLESIASTES 7:1

Right:
A mortar and pestle, the sign of an apothecary.
Old Jewish Cemetery, Prague

Opposite:
A pair of shears, a tailor's trademark. The custom of leaving small stones on top of a gravestone as a mark of remembrance is believed to stem from the ancient practice of heaping large stones on graves to protect the corpses from being disinterred by predators. Votives are also placed on the memorials of revered rabbis.
Old Jewish Cemetery, Prague

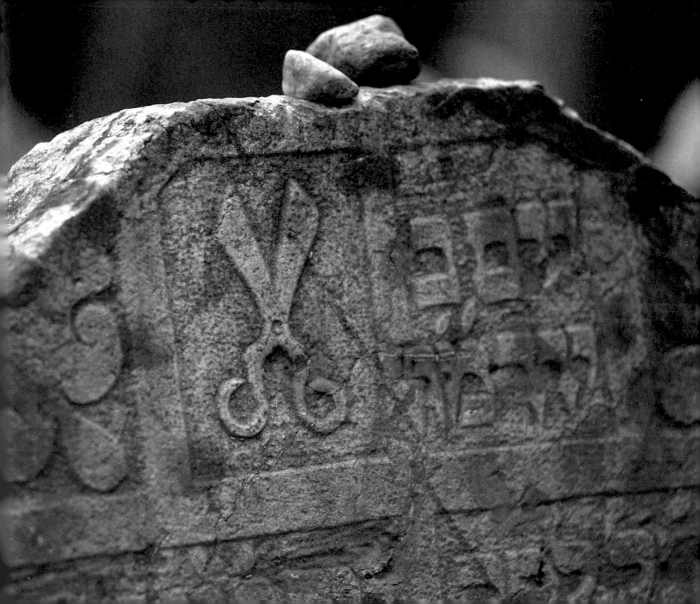

Their grave is their eternal home, the dwelling-place for all generations....
PSALMS 49:12

From the 11th to the 18th century, symbols such as a horseshoe or a wheel could be found above the doors on a town's Judengasse (Jew Lane). One could identify the houses in which the deceased had lived by matching the household emblems with the motifs on their *mazzevot*.

Top and bottom:
A wheel and bellows made of quartz sandstone. Worms, Germany

Opposite:
A shoe, representing a member of the family Schuh. Battonstrasse Cemetery, Frankfurt am Main

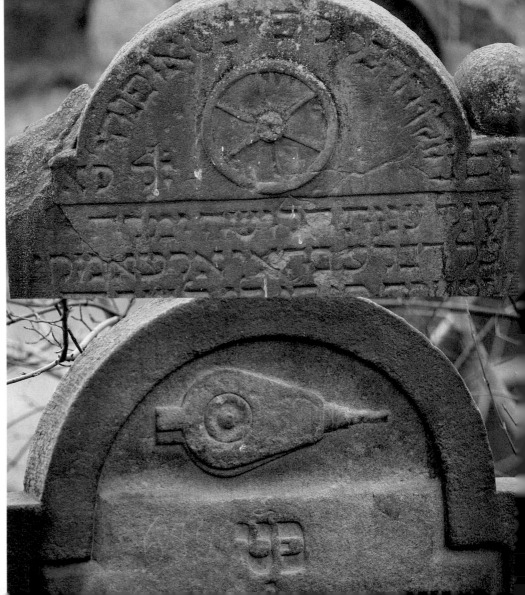

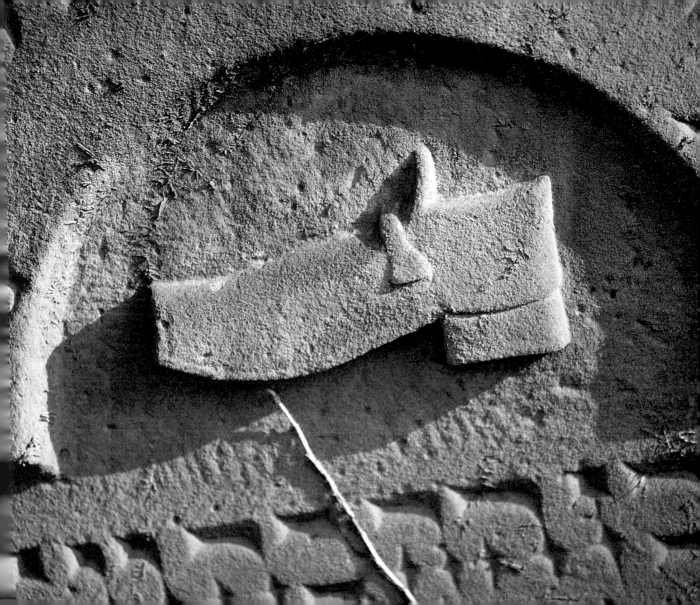

Man then goes out to his work, to his labor until the evening.

PSALMS 104:23

In 1808, Napoleon imposed a law requiring Jews to adopt a family name, in contradiction to their traditional practice of using only first names. Many took the name of their hometown or that of their profession.

Right and pages 120 and 121: Tools of a trade, such as a pair of scales for a money-changer and a plow for a farmer, a ship (representing the Schiff family), and biblical motifs are all to be found in this medieval cemetery dating from 1270. Battonstrasse Cemetery, Frankfurt am Main

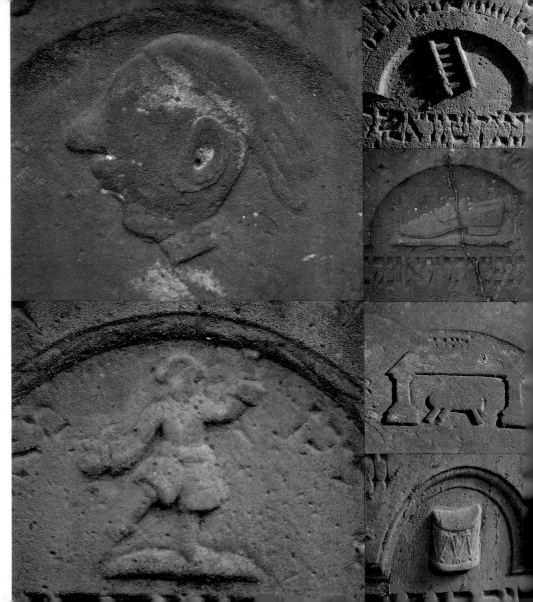

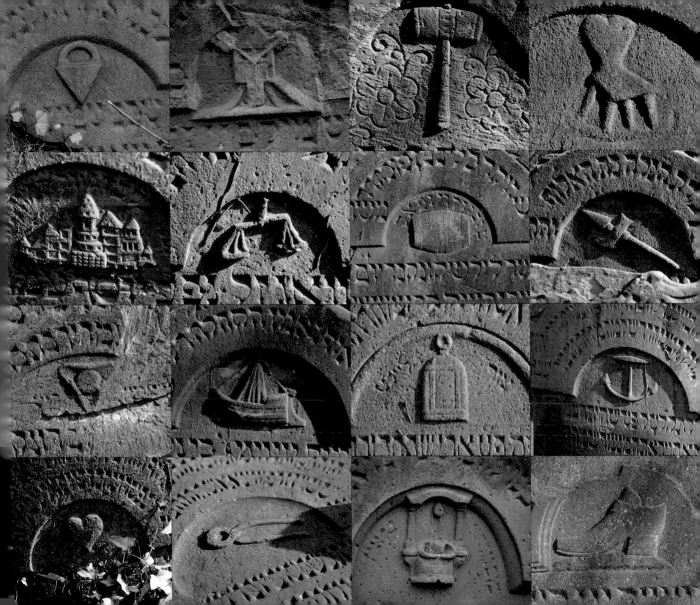

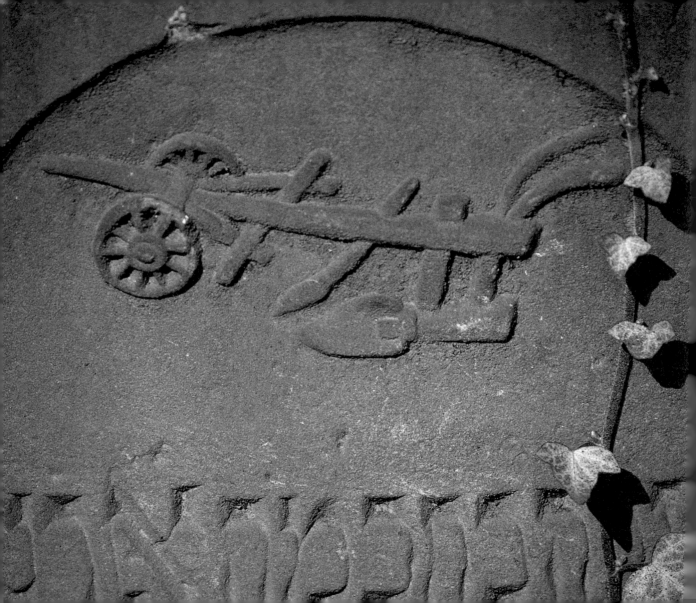

David would take the lyre and play it....
1 SAMUEL 16:23

The musical instruments associated with King David (a harp) and Miriam (a timbrel) are often adopted to represent their namesakes or are used to symbolize musicians.

Above:
San Nicolo del Lido, Venice

Right:
A violin and bow. Old Jewish Cemetery, Prague

Opposite:
Trumpet, lyre, and panpipes. Gesia Cemetery, Warsaw

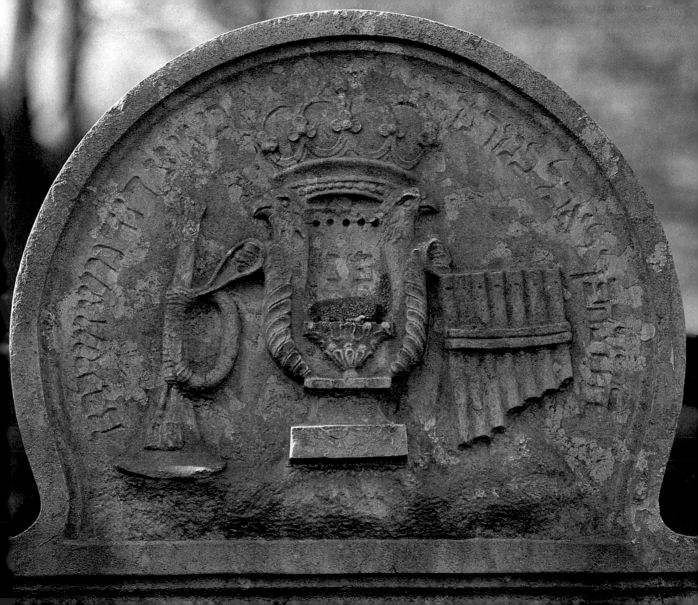

124

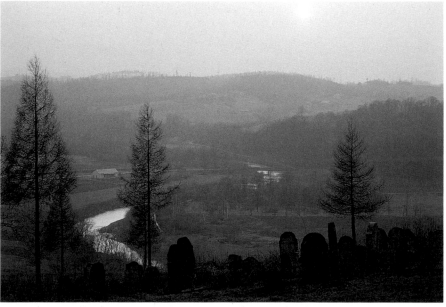

Jewish cemetery. Bobowa, Poland

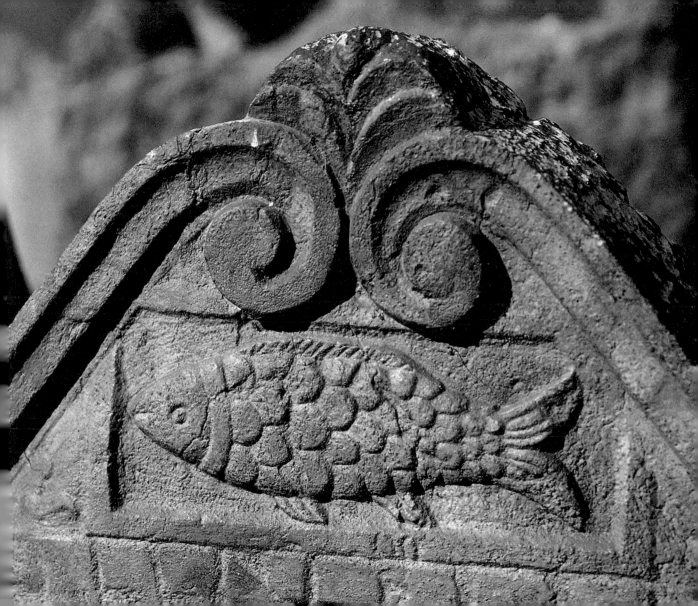

As the fishes in the sea are covered by water....
BABYLONIAN TALMUD, BERAKHOT 20

The fish is a symbol of fertility and rebirth. It is also a messianic symbol of perpetual Sabbath.

Page 125:
A fish represents the family names Fischel and Karpeles.
Old Jewish Cemetery, Prague

Right:
A lobster, often used as the zodiacal sign for Cancer. The same creature appeared in this form on the ceiling of the Chodorov synagogue in Poland.
Rossauer Cemetery, Vienna

Opposite:
On the *mazzevah* of Rabbi Tovia, 5589 (1829), a half-lion, half-fish creature.
Gesia Cemetery, Warsaw

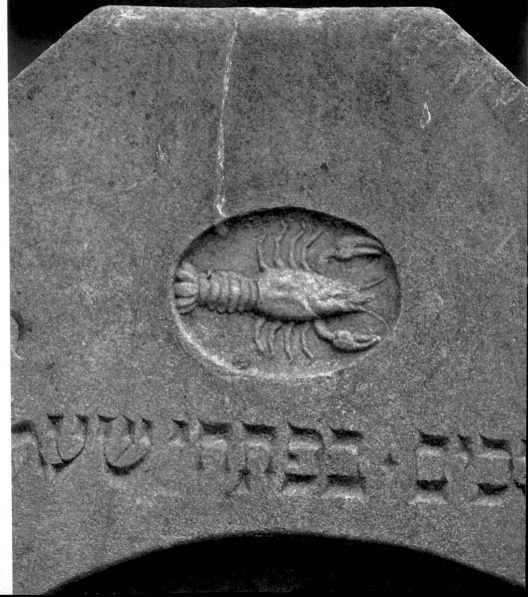

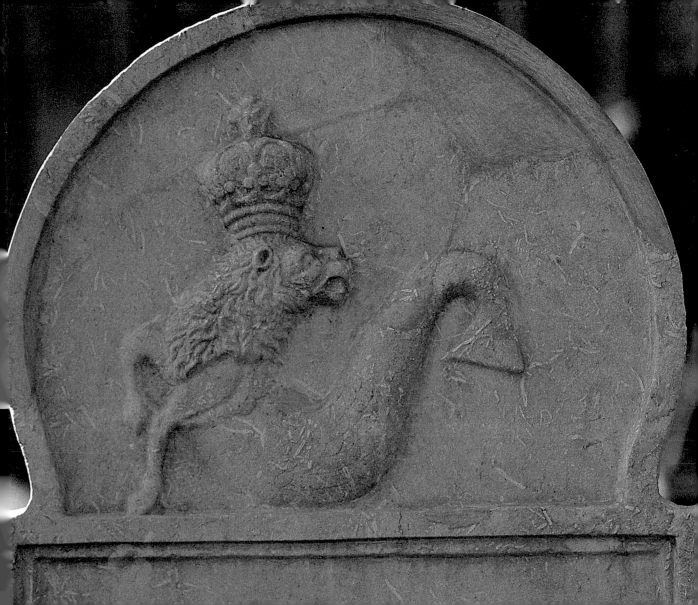

It is better to go to a house of mourning than to a house of feasting....
ECCLESIASTES 7:2

Top:
An image of a house decorates this stone in a cemetery located in a village on the Romanian and Ukrainian border. Jewish cemeteries are referred to as the *bet olam* (house of eternity) or *bet chayyim* (house of the living).
Sapinta, Romania

Bottom:
Frankfurt am Main

Opposite:
This marker is made of Polish sandstone, sometimes known as "weeping stone." Gesia Cemetery, Warsaw

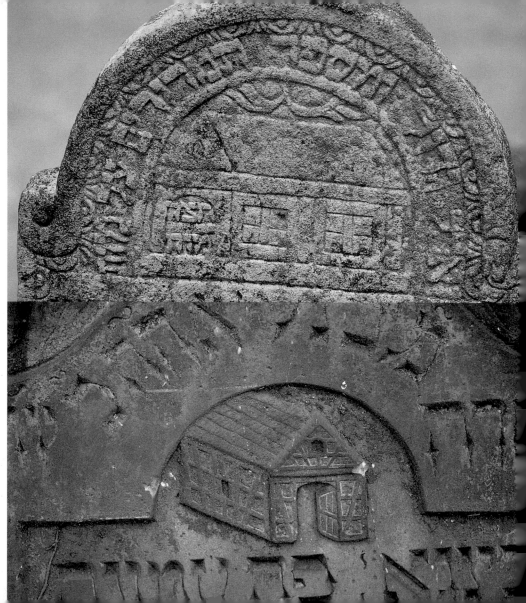

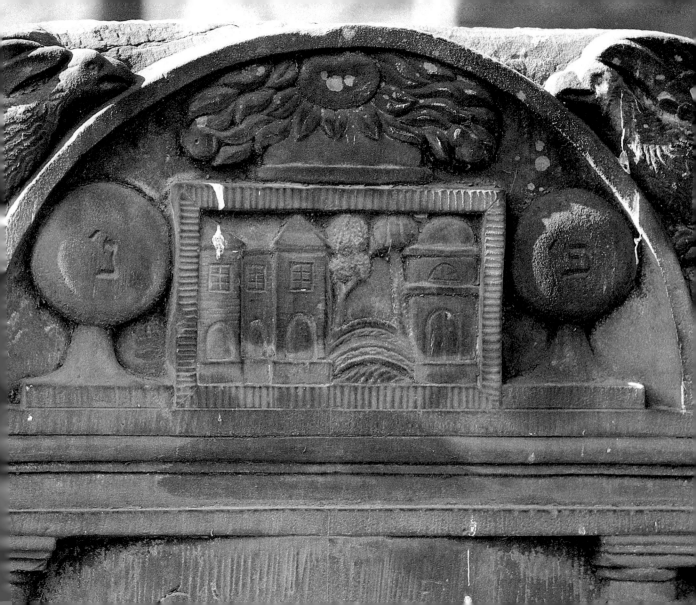

The earth is sated with the fruit of Your work.
PSALMS 104:13

Fruit is a motif commonly associated with the Holy Land, fruitful work, or riches, both material and spiritual. The *etrog* (citron), is one of the Four Species ritually shaken during Sukkot. Symbols of Jewry, the *etrog, lulav* (palm branch), menorah, and *shofar*, were featured on the tombs of the Hellenistic catacombs.

Right:
A vase of flowers and grapes.
Fălticeni, Romania

Opposite:
A cluster of fruit made of pink granite.
15th century, Old Jewish Cemetery, Prague

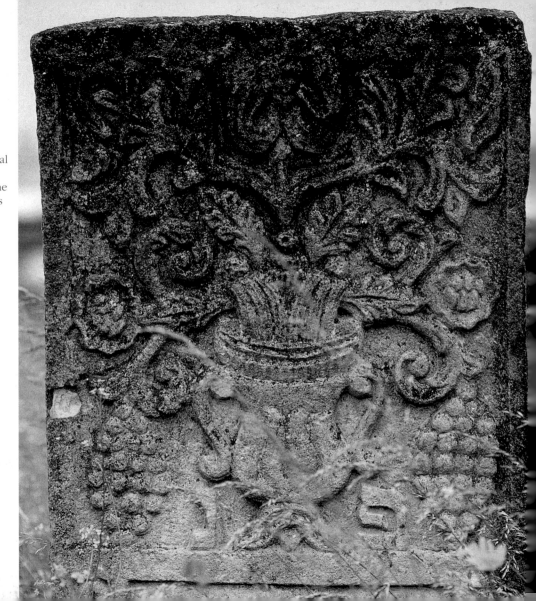

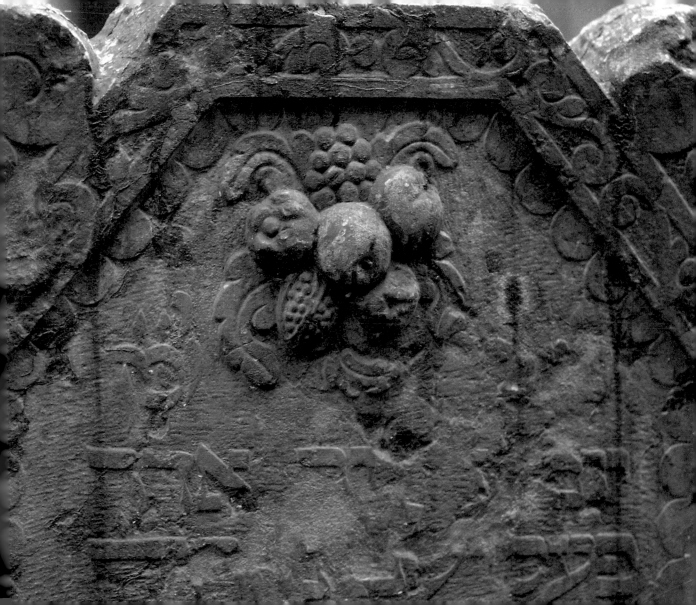

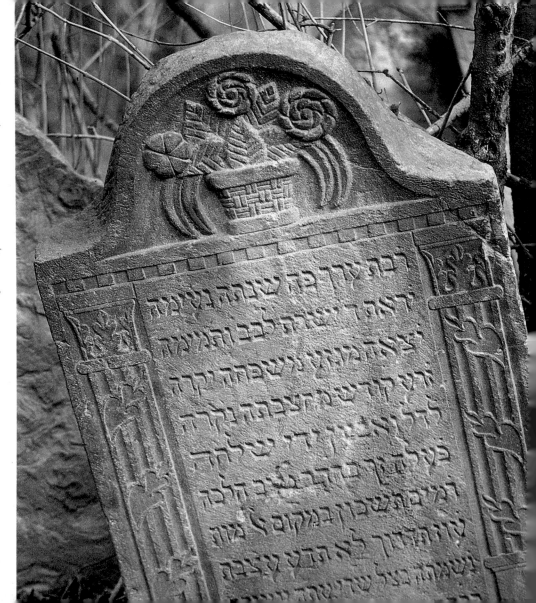

Man, his days are like those of grass; he blooms like a flower of the field....
PSALMS 103:15

Right:
A basket of flowers. In this region, it is quite common to see gravestones painted in red, yellow, and green. Tarnów, Poland

Opposite:
A vase of tulips supported by a pair of rampant lions made of Bavarian limestone similar to that used by Aloys Senefelder when he invented lithography in the late 1700's. Georgensgmünd, Germany

132

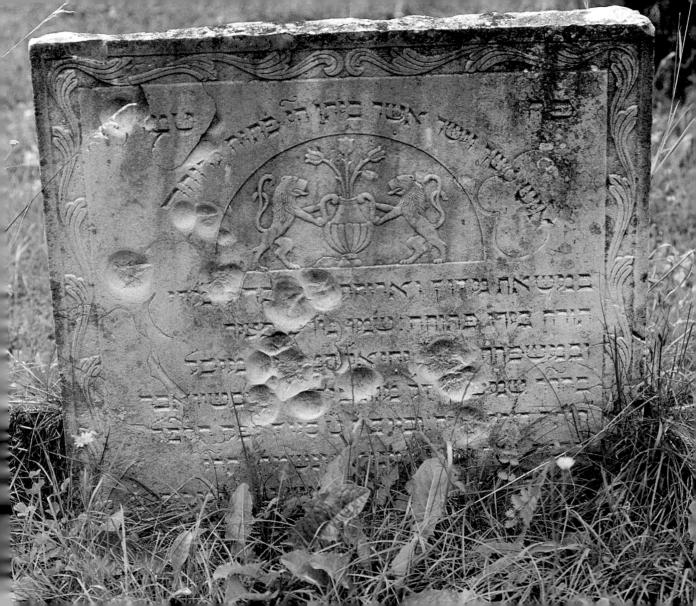

פה

פ"נ איש הלך תמים ה' בדרך תמים נ"ע

שמע את דודי דודי והנדכאים

דורה נדיב פתוחה והיד [...] דל

והשכים [...] ואביון [...] כל

[...] ביתו [...]

The Israelites shall camp each with his standard, under the banners of their ancestral house....
NUMBERS 2:2

After the expulsion of the Sephardim from the Iberian peninsula in 1492, many adopted the names and coat of arms of the Spanish nobility who had sponsored their baptism. On returning to Judaism, most chose to continue using their insignia.

Top:
Insignia of the Vivanti family.

Bottom:
Insignia of the Uzielli family.

Opposite, left:
Norsa family insignia.

Opposite, right:
A woman holding an olive branch and a sword.
San Nicolo del Lido, Venice

134

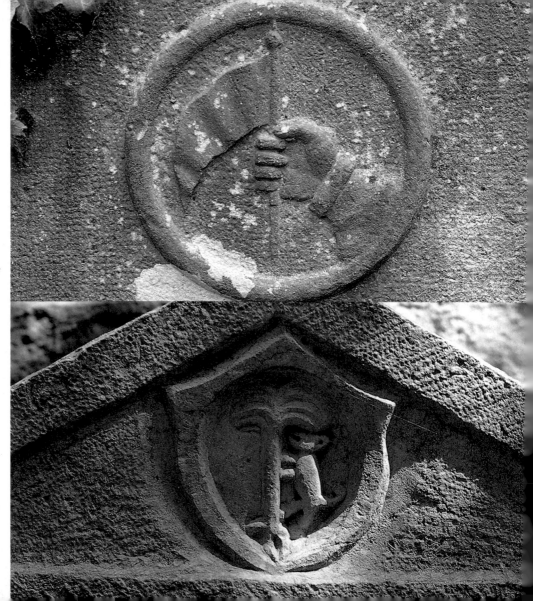

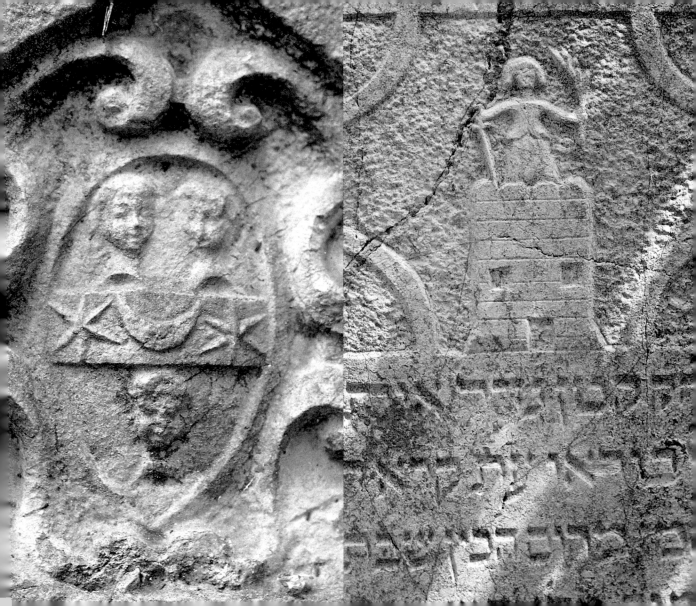

*I have been
a stranger in a
foreign land.*
EXODUS 2:22

The medieval Jews
of Schopfloch,
Germany,
developed a local
patois based on
Hebrew. Over the
years, their non-
Jewish neighbors
learned the dialect,
known as
Lachoudish, an
abbreviation for
lashon ha-kodesh
(holy tongue).
Although there are
no longer any Jews
among the village's
2,500 inhabitants, a
dozen or so of the
villagers still speak
Lachoudish.

Right:
An unusual Hebrew
letter form.
Schopfloch,
Germany

Opposite, left:
Tarnów, Poland

Opposite, right:
Mikolów, Poland

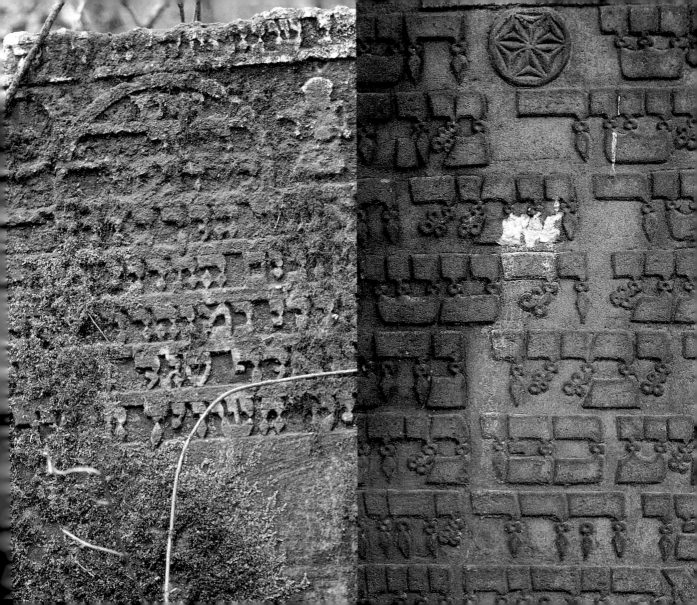

Bezalel knew how to join together the letters that had been used to create heaven and earth.

JERUSALEM TALMUD
YOMA 7

The thicks and thins of the Hebrew characters formed by the scribe's quill were emulated by stonemasons. Due to the exclusion of Jews from the craft guilds prior to the 19th century, much of this work was executed by non-Jews, sometimes resulting in errors in the wording. Gravestones from the 19th century often reflect Victorian wooden typefaces.

Right:
Pappenheim, Germany

Opposite:
Tarnów, Poland

A F T E R W O R D

In an English seaside town, just a few feet from the plot where my parents are buried, is a black granite gravestone with an inscription in gold leaf stating simply the deceased's name and his profession: film producer. Members of this small Jewish community frowned upon this seemingly ostentatious statement; however, in my adopted home of Hollywood, California, where bus stop benches advertise Jewish mortuaries, and station wagon bumper stickers urge the coming of the Messiah, this is a common job description.

Schmuel Gelbfisz (goldfish), the grandson of Zalman, a Hassidic *mobel*, was born in Warsaw, where, it is said, the sign on his family's house was a yellow fish. On emigrating to the United States, Gelbfisz became Samuel Goldwyn, the celebrated movie mogul. At his funeral service, his eulogy was given in Forest Lawn's Wee Kirk o' the Heather chapel, a far cry from the traditional *taharah* house of the former glove salesman's shtetl, where the simple image of a fish may have sufficed on his monument.

In true Hollywood style, other sons of the shtetl are grandly memorialized. The monument of Lithuanian-born cantor's son Asa Yoelson, aka Al Jolson, in Hillside Memorial Park, Los Angeles, bears this inscription on its grand rotunda: "The Sweet Singer of Israel—The Man Raised Up High." This encircles a mosaic of Moses holding the tablets of the Ten Commandments. Below are Jolson's sarcophagus and a nearly life-size bronze statue of the "Jazz Singer" on bended knee with arms outstretched. From this gazebo atop "Mount Shalom," a waterfall cascades several hundred feet down the hillside.

In Hollywood Memorial Park, not far from the grave of the infamous Benjamin "Bugsy" Siegel, is the gravestone of Mel Blanc, the voice of Bugs Bunny and Daffy Duck, whose epitaph echoes the Warner Bros. cartoon sign-off, providing us with a fitting close to this book: "That's All Folks!"

Opposite: Interior of a taharah *house. Ferrara, Italy*

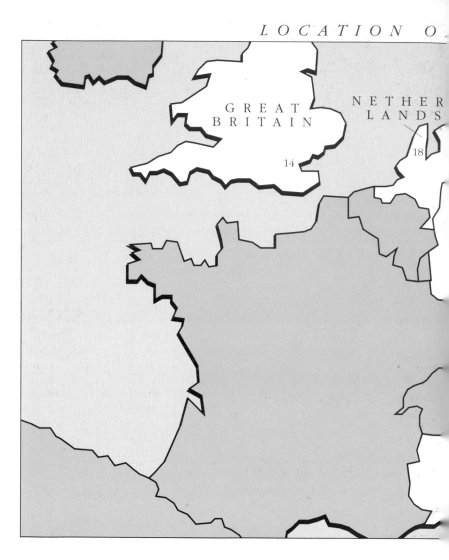

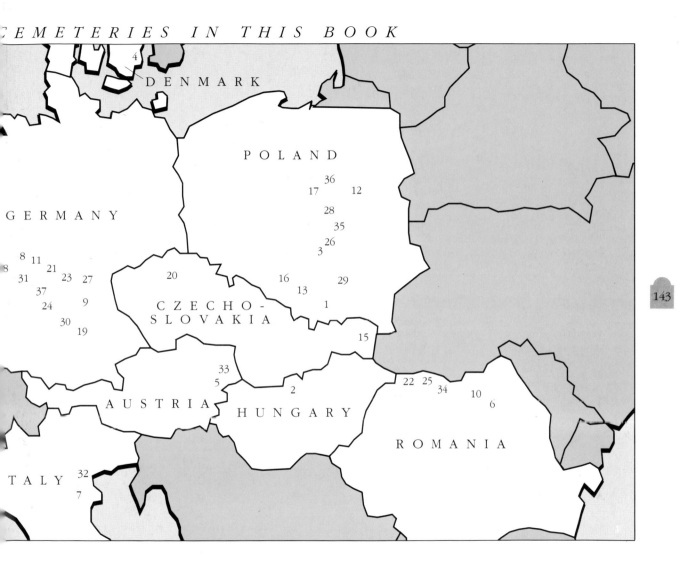

ACKNOWLEDGMENTS

While serving as a young British soldier in Korea, I attended a Passover service conducted by a U.S. Army chaplain wearing the insignia of his corps—the twin tablets of the commandments. I still relish the memory. To Chaim Potok—for his spiritual guidance then and for his eloquent foreword to this book now, some forty years later—I am eternally grateful.

For their invaluable and generous assistance, I wish to express my sincere gratitude to the many Jewish communities and their custodians throughout Europe; Prof. William Fishman; Leah Hoffmitz; The Israel Museum, Jerusalem; Comandante Aldo Izzo; Lady Marie-Noel Kelly; Adaire Klein; Victor Kotowitz; Prof. Peter Kuhn; The Mansell Collection, London; Chavah Ts. Rodrigues Pereira; Gunter and Evelyn Rambow; Hannah Schwartzman; Bruno and Ruth Wiese; The Simon Wiesenthal Center; Kurt Wirth; Design Director Sam Antupit and my editors, Sharon AvRutick and Jennifer Stockman, at Abrams, for their meticulous attention to the book's many details; and, last but not least, my wife, Isolde, who as collaborator and typesetter helped this book come to fruition.

One of several 17th-century baroque faces decorating a tomb. San Nicolo del Lido, Venice, Italy

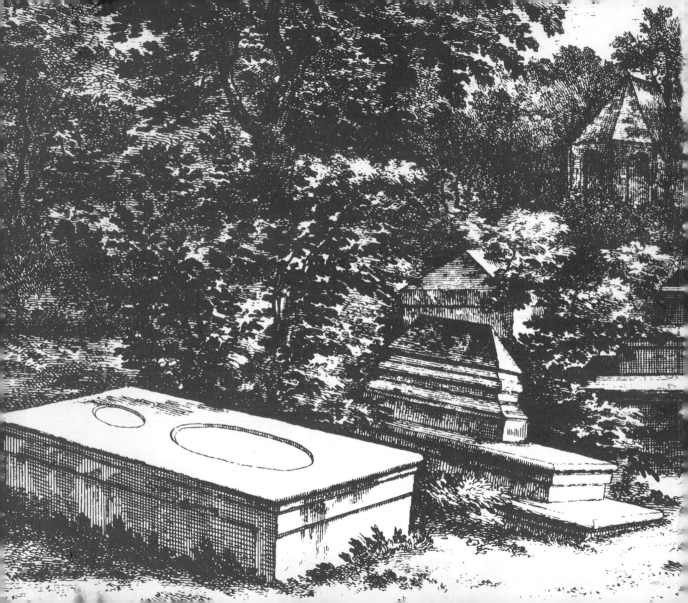